Blue Pixel
Personal Photo Coach

Digital Photography Tips

from the Trenches

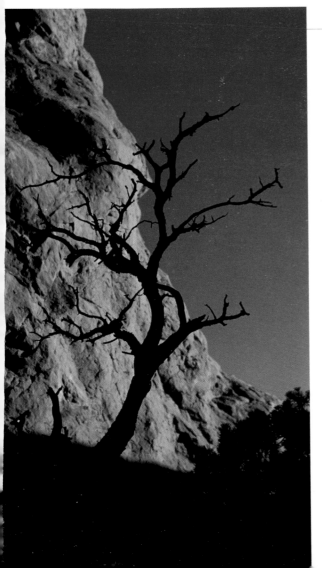

Peachpit
Press

Blue Pixel Personal Photo Coach:
Digital Photography Tips from the Trenches
David Schloss

Peachpit Press
1249 Eighth Street
Berkeley, CA 94710
510/524-2178
800/283-9444
510/524-2221 (fax)

Find us on the World Wide Web at: www.peachpit.com
To report errors, please send a note to errata@peachpit.com

Peachpit Press is a division of Pearson Education

Copyright © 2005 by Blue Pixel, Inc.

Project Editor: Cheryl England
Production Editor: Lupe Edgar
Copyeditor: Elissa Rabellino
Compositors: Myrna Vladic, Owen Wolfson
Indexer: Rebecca Plunkett
Cover design: Aren Howell
Interior design: Charlene Charles Will, Kim Scott

ISBN 0-321-30528-0

9 8 7 6 5 4 3 2 1

Printed and bound in the United States of America

Contents

About the Contributors

Blue Pixel

Blue Pixel (www. bluepixel.net) was founded with one mission: to have leading digital photographers teach their craft from an unbiased, real-world perspective. Blue Pixel has provided its digital photography expertise to a long list of clients, including Microsoft, Best Buy, Adobe Digital Kids Club, the Nikon School of Photography, and the *A Day in the Life of Africa* and *America 24/7* projects. Blue Pixel's staff and associates all share a common outlook on shooting digital: Make it simple, and make it fun.

Nick Didlick

In a 30-year photojournalism career that has taken him around the world and back, Blue Pixel Associate Nick Didlick has been a staff shooter for Canada's *Vancouver Sun* and *National Post* newspapers, as well as the news services Reuters and UPI. He was named Reuters Journalist of the Year in 1988, and his work has also appeared in *The New York Times*, *The Times of London*, *Stern*, *Time*, *Newsweek*, *Vanity Fair*, and

Rolling Stone. Didlick, like Rob Galbraith, was among the world's first photojournalists to switch to digital in 1994, whereupon he reputedly took to taunting film-shooting colleagues with the phrase "If it ain't digital, it ain't news!"

Bill Durrence

Blue Pixel Associate Bill Durrence has 40 years of experience as a professional photographer shooting editorial and commercial assignments and teaching photography in undergraduate academic programs and various workshop/seminar formats. He worked for 14 years in Nikon Inc.'s Professional and Technical Services Department and taught the Nikon School of Photography for 9 years. He is now the lead instructor of the digital edition of the Nikon School of Photography.

Rob Galbraith

As a staff photographer at the *Calgary Herald* in Calgary, Alberta, Blue Pixel Partner Rob Galbraith began shooting digital in mid-1994. His experiences led him to write a book, *The Digital Photojournalist's Guide,* which became the bible of the industry and is now in its fourth edition. One of the world's most respected digital photography consultants and trainers, Rob is also the brains behind Rob Galbraith Digital Photography Insights (www.robgalbraith.com), one of the world's leading digital photography Web sites.

Kevin T. Gilbert

Kevin T. Gilbert, Blue Pixel's managing partner, is a 19-year-veteran photojournalist, five-term president of the White House News Photographers' Association, and former chief photographer of *The Washington Times*. He has been a contract photographer for Discovery Communications, and he led the Corcoran College of Art and Design's digital photojournalism department. His work has appeared in newspapers, magazines, books, and advertising campaigns throughout the world.

Eamon Hickey

Freelance writer Eamon Hickey has published more than 100 articles on digital photography in magazines and Web sites including *Computer Shopper*, *MacAddict*, *digitalFOTO*, CNET.com, and Rob Galbraith Digital Photography Insights.

Reed Hoffmann

Blue Pixel Partner Reed Hoffmann has
been a professional photojournalist for more
than 25 years, working at newspapers in the
Midwest, the South, and the East. He is a
two-time winner of the National Press
Photographers Association Regional
Photographer of the Year award. His clients have included
USA Today, *The New York Times*, Eco-Challenge, and *The
Apprentice*. Reed also teaches the digital edition of the Nikon
School of Photography, as well as numerous workshops
around the United States and the world.

David Schloss

Blue Pixel Editorial Director
David Schloss has worked in
the technology and photogra-
phy fields for 20 years. He
has written for *Photo District
News* (where he is the technology editor and new products
editor), *Time Digital*, *On*, *MacAddict*, MacCentral.com, and
more. He has also written for corporate clients ranging from
Adobe Systems to Microsoft. His photography has appeared
in numerous magazines and Web sites, including *Mountain
Bike Magazine, Photo District News, Paddler Magazine,*
Gearhead.com, and GORP.com.

Michael A. Schwarz

Photojournalist and Blue Pixel Associate Michael A. Schwarz is a former staff shooter at *The Atlanta Journal-Constitution*, the Associated Press, and the Gannett Rochester Newspapers. He is a three-time nominee for the Pulitzer Prize and was a recipient of the Dag Hammarskjöld Award for Human Rights Advocacy Journalism. His work has appeared in *National Geographic*, *USA Today*, *Fortune*, *Life*, *Time*, *The New York Times*, *People*, *Newsweek*, and *Forbes*, among many other publications.

How to Use Your Digital Camera

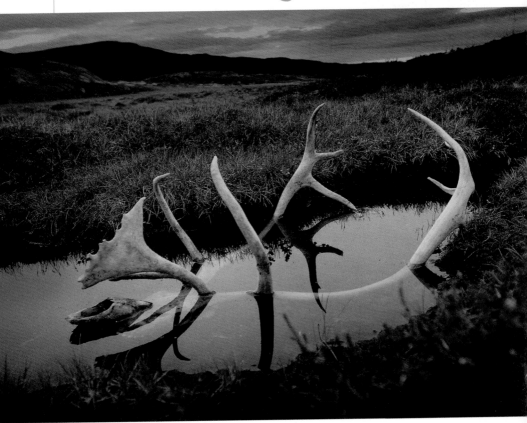

I Spent a Lot of Money on It and Want

to Take Great Pictures, Already

IF YOU ARE LIKE THE MILLIONS of people who own a digital camera (more than 22 *million* people bought a digital camera in 2004 alone), you probably based your decision to purchase it on the wonderful promise that digital photography offers: no more film costs, instantaneous sharing of images, and the ability to improve your photography thanks to the feedback from your camera's LCD screen.

All too often, though, people are disappointed with their early digital photographic attempts. It's *cool* that digital is so instantaneous, but sometimes all you can tell is that you took a lousy picture, quickly.

Part of this has nothing to do with the digital camera. Lots of people take really lousy photographs with film, only there's such a long time between pressing the shutter release and getting the photos back from the lab that people forget what the photograph was supposed to look like in the first place.

Despite what the camera manufacturers will tell you, a digital camera is more complicated than a film model. A shutter release button and a zoom switch are just about all that a point-and-shoot film camera can offer. But a digital camera has lots of buttons, menu choices, connector cables, and more. Sheesh, it's enough to frighten just about anyone.

Once you work past what I call the *Scary Control Interface* on the back of your camera, though, you'll find that it takes great pictures and that it can really help improve your photography. Before you know it, you'll be taking photos like those scattered throughout this chapter and the rest of the book.

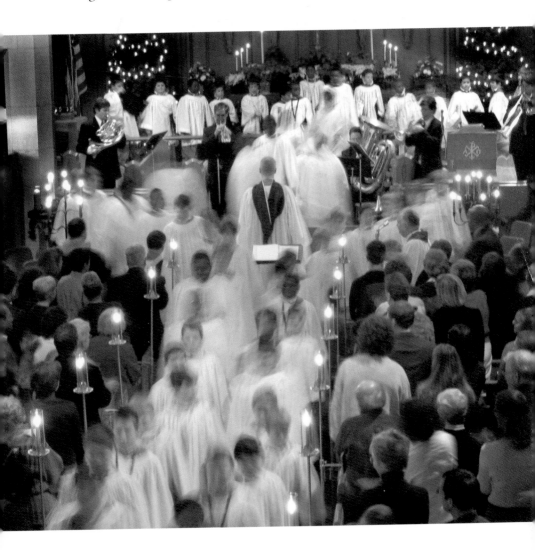

All You Need Is a Coach

"If only," I hear you saying, "I could get someone to show me
how to use this camera—someone who will explain the concepts
of photography, the benefits of digital, and the steps needed
to share my pictures with the world. Heck, my kids have a
soccer coach; why can't I get some sort of, well, photo coach?"

What you are holding in your hands is your own personal
PhotoCoach. (Please hold me gently—I bruise easily.) This
coach won't make you run laps or "drop and give me 20," but
I will show you how to get the most from your digital camera.

A number of years ago, a group of professional photographers founded a company called Blue Pixel. (If you read enough of this book, you'll figure out why.) The Blue Pixel folks (sometimes we call ourselves Blue Pixelers) were all pioneers in digital photography, having converted early on in the history of the new technology. News photographers, sports shooters, portrait photographers, and nature shooters, we all recognized digital's potential.

More than a decade ago, when we all started using digital cameras, the technology was incredibly crude—even the most simplistic point-and-shoot camera today can out perform the heavy and slow behemoths we had to carry around. Instruction manuals were scarce, and good information on the pitfalls and benefits was even more difficult to come by.

If it was tough for a group of seasoned photographers to adapt to the new technology, what must it be like for others? The Blue Pixel staff decided to start providing digital training to corporations and individuals, and over the years we've honed that training to create our PhotoCoach team. Our goal is to provide information that can help transform someone with a confusing gadget and lots of questions into a photographer with a digital camera and plenty of ideas.

Our Just Show Me How Tour travels the country providing group training on digital concepts to help amateur photographers. This book is an extension of the ideas behind that tour, a sort of hands-on one-on-one intensive session. (Albeit a session that you interrupt in order to watch *CSI: Las Vegas* and then pick up again later...).

The book is designed to be open and friendly, and to help you get the most out of your camera purchase. Along the way we've sprinkled tips and some thoughts about the topics, and provided step-by-step guides to performing many of the crucial tasks in digital.

Most of all, though, we'll show you how to become a better photographer by maximizing the tools you already have, and we'll explore some of the ways that the pros approach different situations. We're your personal—and very experienced—PhotoCoaches.

TIP

We've designed this book for digital photographers, but it can help anyone with a camera. The principles of photography haven't changed just because many cameras being made today don't use film. Whether you've been a digital photographer for years, have just purchased your first megapixel wonder, or vow that you'll never give up shooting print film, this book is for you.

Film photographers will obviously not be able to use the tips on sharing and printing images (unless they have a film scanner), but those sections will provide a great insight for those teetering on the edge of switching, or those wondering about the magic of digital photography.

A Digital SL-What?

There are two popular types of digital cameras on the market for amateur photographers: the point-and-shoot and the digital SLR.

The term *point-and-shoot* is a bit misleading—it's used to refer to any compact camera without interchangeable lenses. Point-and-shoot was a marketing term coined by someone at a camera company who noticed that most people with compact cameras don't take the time to compose their shots. These customers wanted a camera that could just be aimed toward the subject and could capture a picture at the press of a button, unencumbered by dials or switches.

If I have my way, you'll never "point and shoot" again, as that's the one certain way to get a lousy photograph. We still call these cameras point-and-shoots, since that's what the companies insist on calling them. Just please don't think of them that way.

A *digital SLR* (single-lens reflex) camera is distinguished by the interchangeable lens on the front. (Some companies, though, make digital SLR cameras now that have a fixed lens and screw-on attachment lenses (see Chapter 12).

Some of the first portable cameras—the ones you see in movies about the Roaring Twenties, for example—had two lenses on them, one for the focusing and one to take the picture. These were *twin-lens* cameras. A camera with one lens for both capture and focus is a *single-lens* camera. *Reflex* is a term that has to do with how it focuses.

A digital SLR (or dSLR) has a number of advantages over a compact point-and-shoot. The interchangeable lenses make it easy to compose your photograph in different ways (see Chapter 2), and the camera's metering system and shutter system are usually more advanced (see Chapter 3). dSLRs universally have a flash hot shoe (see Chapter 4) that allows them to make use of sophisticated add-on systems.

Show Me the Way

Whether you own a point-and-shoot or SLR camera, we can help. This book is divided into sections that group topics together. The first section (Chapters 2 through 4) talks about the mechanics of photography, and this is where I'll introduce you to the concepts behind photography and how it works. The focus here will be on familiarizing you with the operation of a camera, allowing you to take more creative pictures.

The next section (Chapters 5 through 8) is devoted to everything that happens after you push the shutter release button. This section is all about the advantages of digital photography and the info you need in order to share, print, and save your images.

Next (Chapters 9 through 11) I'll turn to some common photographic challenges and look at ways to better handle shooting in everyday types of photo opportunities, such as family photography, action sports (everything from Little League to windsurfing), and even artistic photos (like landscapes and macro shots).

Finally, in Chapter 12, I'll talk about the must-have and should-probably-have gadgets that'll turn your camera into a tool you can use more creatively. I'll cover everything from batteries to bags, explaining the way they work.

At the end of each chapter you'll find a story from the Blue Pixel PhotoCoaches—something that happened to one of us that helped us understand the importance of the topic at hand. Like a conversation with a professional photographer over a cup of joe, these little anecdotes show how common it is to run into problems and how to best cope with them (even if you're photographing the president!).

Don't feel that you need to read the book chapter by chapter—you can turn to a section on a topic that you're having trouble with and go back to the rest later. At each step are references to any other important background information from other chapters, as well as quick sidebars and tips to bring you up to speed if you've missed some information.

Most of all, though, remember that the single best thing you can do to improve your photography is to *take lots and lots of pictures*. This is the beauty of digital—you can take as many photographs as you want and never run out of film again.

With this book, you'll never again have to guess about the best way to take a picture—you've always got your personal PhotoCoach right there with you.

How to Compose
Your Pictures

I'm Sick of Cutting Off People's Body Parts and

Having Telephone Poles Stick Out of Their Heads!

THE PHOTOCOACH ONCE GOT A FORTUNE cookie that read, "A journey of a thousand miles begins with a single step." Good saying for a piece of paper stuck inside a cookie.

You can't get anywhere in life unless you start off on the right foot, and that's no different when it comes to photography. A picture is a visual story—it's a moment preserved in time to share with other people. You wouldn't tell a story by giving someone the ending first, then going back to the beginning, and then jumping to the middle. You have to compose your words in a way that people will understand.

Likewise you can't tell a story through photography if you don't compose your images well. Your PhotoCoach has seen a million photographs in his day. Some of them were good, some of them were bad, and some of them were, well, let's just say they were *worse than bad*. There are lots of things you can do to compose a great photograph so that it tells exactly the story you want it to tell (**Figure 2.1**).

▼ FIGURE 2.1: A photo's composition should make it clear what is important.

Compose Yourself

Since the dawn of time, human beings have had a pretty good idea about what makes up good composition. Without a doubt, as prehistoric humans painted scenes in the caves of Lascaux depicting the day's hunt using nothing but hand-ground pigments, someone came up to them and said, "The deer would look better over there."

You can tell right away when something looks bad, though you might not be able to put your finger on exactly why it doesn't appeal to you. For ages people have studied composition, looking for rules that would give artists guidelines for creating artwork that looks *right*. But those rules remain elusive.

When taking photographs, people often forget to *think* before they shoot. Too many people just thrust their camera in the direction of their subject and press the button quickly. A camera is a tool, and, like any other tool, it needs to be used correctly. You shouldn't press the shutter release button without thinking a bit about what you want your photograph to look like.

The mind has the ability to focus on what it's interested in; a camera doesn't have that ability. All too often, when people show off a photograph, they have to point out what's important in the scene. "Here's a picture of my uncle Al. He's the one over by the car," they might say. Your PhotoCoach has a saying: A photograph is like a joke—if you have to explain it, you've done something wrong.

Follow these PhotoCoach-approved guidelines and you're guaranteed to get a better shot (**Figures 2.2a, 2.2b**, and **2.2c**).

▶ **FIGURE 2.2A:** This happy family group is just too far away from the camera to seem like the most important subjects in the photo.

▶ **FIGURE 2.2B:** Here the family is much closer to the viewer but, alas, not everyone has feet.

▼ **FIGURE 2.2C:** Now this is much better. The kids are close and well-posed, the background is interesting, and no one is missing any body parts.

Check Your Corners

Before you press the shutter release button, take a few seconds to
look around. Photography makes some people a bit excited—
hand them a camera and they rush to take pictures, worried that
they'll miss a priceless moment if they don't push the button fast
enough. There are some times when it's better to rush and get
something than to take your time and miss the shot, but that's a
pretty rare occurrence if you're prepared.

Pay attention to the areas around your subject. While looking
through the viewfinder, run your eye around the corners of the
frame to see if any distracting objects are poking into or out of it.
Check the edges of your frame also and make sure that there aren't
mountain ranges or tree limbs or other distracting objects to
draw the viewer's eye away from your subject. Know, however,
that even moviemakers sometimes forget these simple tips. In the
movie *Rumble in the Bronx*, Jackie Chan fights the bad guys with
a clear view of giant mountains in the background. Of course the
Bronx doesn't have mountain ranges, but Hong Kong does.

TIP

The biggest reason that photos end up in the Bad Photo Hall of
Fame is the telephone pole. This necessity of modern civilization
ends up in all sorts of otherwise great pictures. Look out for tele-
phone poles appearing to sprout out of someone's head, coming out
of parked cars, and causing general mischief in your photographs
(**Figures 2.3a** and **2.3b**).

On the other hand, adding to your frame sometimes enhances the shot. Framing a photograph of your mom so that she is standing beside a rose bush might add a nice touch, while taking a photograph of your children enjoying themselves in the playground might be more interesting with parts of the slide or swing set visible (**Figure 2.4**).

Colors, interesting shapes and textures, and repeating elements can also add to your photograph (**Figure 2.5**). Look for things that will make your photograph stand out without introducing annoying distractions, and include them in your picture.

◀ **FIGURE 2.3A:** If you're not paying attention, you'll end up with some pretty nasty surprises in your photos, such as the telephone pole mysteriously sprouting from this boy's head.

▼ **FIGURE 2.3B:** In this shot, not only has the telephone pole been eliminated, but the boy is placed in a much more interesting manner.

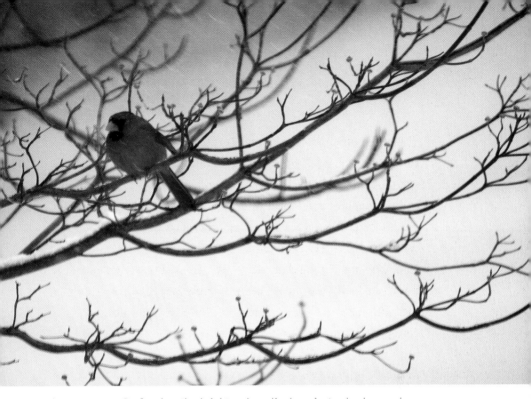

▲ **FIGURE 2.4:** By framing the bright red cardinal against a background of barren branches and the white sky of a winter day, the photographer has created a beautiful image that tells a better story than a photo of the cardinal alone would have.

▼ **FIGURE 2.5:** The contrasting textures and bright colors enhance this photo.

Move Over

If you've checked the edges of your frame and don't like what you see, move around and try composing your shot again. Too often photographers direct their subjects to move when they could move just as easily and end up with a better shot. If you're standing against the edge of a cliff and moving might cause you to plummet like Wile E. Coyote, then you might not want to move, but otherwise look for more interesting places from which to take your photograph.

Nothing says that a picture needs to be taken at eye level, either. When professional photographers are on assignment and getting bored, they often start looking around for strange places from which to take a photograph. Some amazing shots have been taken high up on a building's rafters or from some other nontraditional location.

You don't have to go to such great lengths, however. Simply moving around to see how things look through your viewfinder or

▼ **FIGURE 2.6:** Most people would photograph a night scene straight on(left). But when you simply change your viewpoint to look up, the photograph becomes dynamic (right).

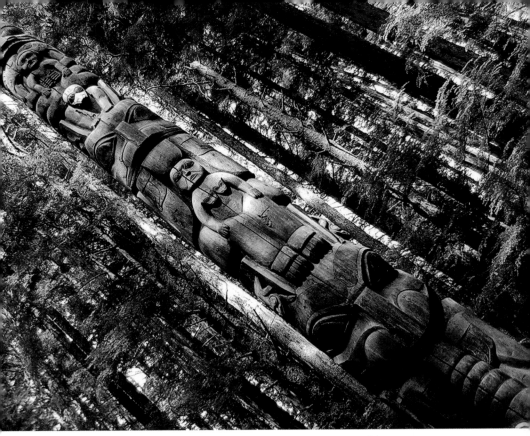

▲ **FIGURE 2.7:** This photo of a totem pole would be good even if shot straight on. But by tilting the camera, the photographer has created an extremely eye-catching photo.

LCD can present some surprising results (**Figure 2.6**). Also, try tilting the camera to get different angles and unique compositions. This is especially true for buildings and other interesting architecture or items (**Figure 2.7**). And since you're shooting with a digital camera, without worry you can take lots of pictures just to see how things look from different viewpoints.

TIP

I often bring a folding stepladder along on shoots in order to experiment with different angles. Don't be afraid to climb up on a chair or other sturdy object for a better photograph.

Get Closer—Now Get Farther Away

When people talk to each other, they generally stand just a few feet apart, yet most people back up to take a photograph. On top of that, most point-and-shoot digital cameras come with lenses that default to the widest setting. Shooting with a wide-angle lens has the same effect as backing off even further. So while we feel comfortable talking to each other from just a few feet away, we end up taking pictures that look as if we were a dozen feet or more from our subject.

Moving in closer to your subject is a great compositional trick that allows you to capture more of the feeling and detail of your subject (**Figures 2.8a** and **2.8b**). This doesn't work well for things like landscapes, but it serves other photographic subjects well.

TIP

With digital cameras, especially lower-megapixel models, it's vital to remember to perform any cropping in the camera. It's best to cut off any useless portions of your photograph while looking through the viewfinder rather than do it in an image-editing program. Getting the right camera-to-subject distance means that you'll have more image data to work with when you go to print later on.

◀ FIGURE 2.8A: There are too many distracting elements in the background to allow the design on the window to pop out.

◀ **FIGURE 2.8B:** Taking a close-up of the design allows you to see much more detail and also creates a more interesting photo compositionally.

▼ **FIGURE 2.9:** A wide-angle lens lets you take photos where both foreground and background items are in focus.

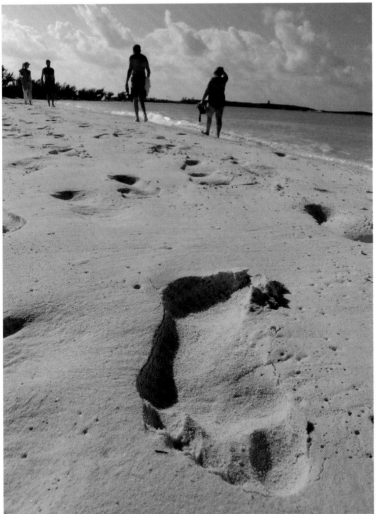

For landscapes or other photos in which you want to capture as much of a scene as possible, you'll want to either back off or use a wide-angle lens. Most digital point-and-shoot cameras include a wide-angle lens. Digital SLRs and some point-and-shoot cameras also accept add-on wide-angle lenses.

A wide-angle lens lets you capture interesting things in both the foreground and the background (**Figure 2.9**). By moving your subject fairly close to the lens and setting a deep depth of field (Chapter 3), you can shoot two interesting subjects at once.

Don't Cut Me Off

If telephone poles poking out of heads are the most common photographic composition problem, then the odd photo-amputation of body parts is easily the second most common one. Without thinking, people often crop their photos in ways that eliminate much-needed limbs from the frame. The choices of what to eliminate and what to leave in are often amusing. Trees will loom above the subject of a portrait while his or her feet are cut off at the bottom of the frame.

There are some occasions, however, when it's necessary to crop out parts of your subject in order to follow other rules of composition. If you're getting physically close to your subject, you might need to crop out body parts to get a shot. Just do so carefully (**Figures 2.10** and **2.11**).

TIP

Some crops work better than others. In a face portrait it makes more sense to crop a person at the waist than at the knees or shoulders. But, for heaven's sake, try not to crop people at the joints—an arm without a hand looks strange, for example.

◀ ▼ **FIGURES** 2.10 and 2.11:
Despite the fact that the subjects
in these photos have been cropped,
the compositions still work because
the natural feeling still exists.

The Oldest Rule in the Book

There are, of course, no hard-and-fast rules about composition, and any time someone tries to come up with rules, a whole group of artists becomes famous by breaking every last one of them. Still, one set of rules to keep in mind is the *rule of thirds*— a simple composition tool that lends itself to making creative pictures (or drawings, paintings, and so on).

Too often people plop their subject square in the middle of the frame. That works fine when you're looking at someone with your eyes, but it frequently results in a terribly dull picture. The rule of thirds separates an image into nine rectangles by dividing the area with two horizontal and two vertical lines. The basic idea is to center your subject on one of those pairs of inter-secting lines rather than smack-dab in the center (**Figure 2.12**).

Some cameras have a rule of thirds composition mode that overlays this grid onto the image on your LCD. Not only is this helpful for composition, but it's also a great way to make sure your camera is level when you're photographing a landscape, a building, or any other subject with horizontal or vertical lines.

TIP

Here's a tip from art school: An image is often more compelling if the subject touches two sides of the frame. This is an exten-sion of the rule of thirds.

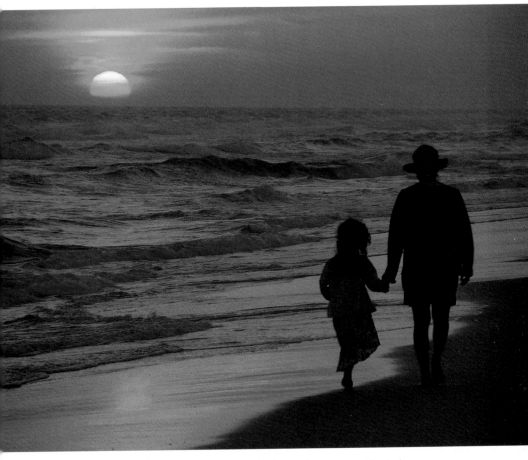

▲ **FIGURE 2.12:** By following the rule of thirds to place your subjects in areas other than dead center, you can create much more interesting compositions.

Composing with Light

Illustrators work with ink, painters create with paint, sculptors use clay, and photographers use light. Without light it would be impossible to make a photo. So proper use of light is just as important for composing your pictures as the way you hold your camera or arrange your subjects. Lighting can make or break a photograph (**Figures 2.13a** and **2.13b**).

In the good ol' days of film photography, people were taught to always keep the sun behind them. This prevents your subjects from being *backlit* and losing detail but doesn't do anything to flatter them. Backlighting occurs when the main source of light comes from behind the subject. Without any additional fill flash

▶ **FIGURE 2.13A:** This photo was taken on a cloudy day in poor light. The result is uninspiring.

FIGURE 2.13B (FAR RIGHT): Photographed later in the day when the light was softer, the same scene has a much warmer tone.

(Chapter 4) the subject of a backlit photo is likely to end up having dark shadows on the face or becoming a silhouette. That's a cool technique if it's what you're after, but otherwise it will ruin a good photograph.

It's better to have the main source of light to your side. This adds detail and texture to your photographs as the shadows and light play over your subject.

Oh, What a Beautiful Morning

The time of day and the weather can really change the way your photograph looks, so you'll need to pay attention to atmospheric conditions as well as subject placement.

The first few hours of the morning and the last few hours before sunset are often called the *golden hours*, and some photographers will only work during these periods. Because the sun is low on the horizon, its light passes through a lot of our atmosphere, becoming diffused and casting everything in a warm soft glow.

By contrast, the light of midday is directly overhead and usually casts harsh shadows on a subject. Without something to modify this light (Chapters 4 and 12), even the best-composed picture will come out looking dull and washed out. You can't always take your photographs in the early morning, however. Do keep in mind, though, that the time of day can change the way your photographs look .

The weather can affect your photograph as well. A cloudy day makes photographs grayer but also helps to lessen those tough midday shadows. Rain makes photography more challenging because of the low amounts of light available, and during a really bad storm you might need to use a flash even at midday.

If the available light is too dull or too harsh to take a nice photograph, think about other ways to compose your scene. Instead of taking a full-size photo of a person or object in the sun at high noon, take some macro photographs of your subject instead (**Figures 2.14a** and **2.14b**). You can also switch to some sort of shooting mode in which the quality of the light is less important than the presentation of the subject.

◀ **FIGURE 2.14A:** The lighting at noon for this picture was less than ideal.

▼ **FIGURE 2.14B:** Moving in to capture just one element of the scene vastly improved the photo.

Running of the Bulls
Making your photo stand out from the crowd

If you're assigned to shoot something that's been photographed to death, how do you make your picture stand out? Nick Didlick solved that dilemma with an unusual composition when he was assigned by Canada's *National Post* newspaper to shoot the Running of the Bulls festival in Pamplona, Spain, in the summer of 2000.

"The first day I got there," Didlick says, "I walked the path the bulls would take through the streets every day, trying to come up with a picture in my mind that would be super dramatic of an event that's been heavily documented for years.

"The other photographers told me about this one corner. It's a hard righthand turn where the bulls slip on the cobblestones, and generally that's where all the pictures happen. So the first day of the festival, I decided to stand on the fence at the outside of that corner and get a picture from there. The pictures were OK, but you've seen them a hundred times before."

Didlick, however, had noticed something. "The bulls came charging up the street, slid into the fence, and hit right below me. When one bull was struggling to its feet down below me, I thought, 'That's where I should be. Looking up at the bull.' Eye level is the most boring angle, and that's where I was on the fence: eye level. With composition, you have to previsualize and paint the scene [in your mind], and then go out and capture that." Didlick also knew that a very wide-angle lens would exaggerate the size of a looming bull shot at ground level.

Didlick couldn't be at the bottom inside edge of the fence himself, of course, but one of his cameras could. The next morning, he attached the camera—a $5,000 Nikon with a very wide-angle lens—

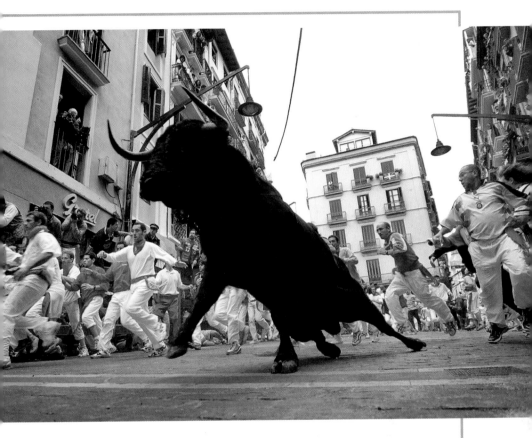

to a clamp that he had mounted on the bottom railing of the fence. "The local Spanish photographers were in horror," he says, as they watched him mount his fancy digital camera in the path of the bulls. Didlick would trigger the Nikon remotely with a radio device synchronized to fire the camera whenever he pressed the shutter release on his second camera. He planned to hold this second camera and shoot from the standard fence-top spot because, he explains matter-of-factly, "one money shot you can't miss is a bull goring some guy and throwing him over his head."

"So the second morning," Didlick continues, "the bulls come running down the street, they slip on the cobblestones, everything's looking good, I press the shutter button, a hoof kicks the camera off the railing, it goes flying back about 6 feet into the crowd, and I end up with a bunch of pictures of peoples' feet." The kicked camera was still working, so the next morning Didlick moved it 10 feet farther down the fence and tried again. It wasn't far enough; he ended up with the same result, complete with flying camera and pictures of feet.

"When one bull was struggling to its feet down below me, I thought, 'That's where I should be. Looking up at the bull.'"

"The third morning," he says, "I move it 15 more feet down the fence. By now, the Spanish photographers are taking pictures of *me* because they think it's a hilarious story: the crazy Canadian letting the bulls kick his camera around.

"So, the bulls come out, they come charging down the street, I push the button, they smash into the fence, this time missing my camera by about 5 feet, and I have this great picture of a bull sliding towards me with his brakes on as he's hitting the fence. I transmit the picture to the paper, and they run it huge. The next day I pick up the local Spanish paper, and there's a picture of me attaching my camera to the railing."

—EAMON HICKEY

How to Use Your Digital Camera's Settings

Everything You Need to Know About How a Digital Camera Works (but Were Afraid to Ask)

EVERY CAMERA EVER MADE, from the first wooden box camera to today's compact and efficient digital cameras, works exactly the same way. At this point you're probably thinking that I've lost my marbles—there's no way that a 19th-century hunk of wood does the same thing that your sleek, sexy 21st-century technological marvel does.

While there *are* amazing and obvious differences, the heart of a camera and the fundamental principles that enable a camera to take a picture haven't changed a whit in more than 100 years.

The concepts of *shutter speed, aperture*, and, more recently, *white balance* have remained exactly the same since the dawn of photography, and they are essential to understand if you want to take good pictures. (They're even *more* important to understand if you'd like to take great ones.) They're all connected, so it's also vital to understand how they relate to each other.

Luckily, the rules of photography are pretty simple once you get the hang of them, so here's the Blue Pixel PhotoCoach's plain English guide to understanding your camera.

I Shutter to Think of It

What exactly happens when you press the button on your camera? What is that clicking noise that everyone listens for, anyhow? And how come I can turn that noise off on some digital cameras?

At the most basic level, a camera is a lightproof box with a covered hole in it. When it comes time to take a picture, the hole's cover needs to move away from the opening for a moment to let light strike a digital sensor (or film, if you're using a film camera). Inside most cameras is a small *shutter*, which works very much like a set of Venetian blinds you might hang over a window. That shutter hangs over the hole like a drape. When you press the *shutter release* button to take a photo, the shutter moves aside and lets light hit the digital sensor, and then snaps quickly back into place. Since the sensor in your camera is very sensitive to light, that hole only needs to be uncovered for a fraction of a second in order to let enough light in to make a picture.

TIP

Don't forget that with fractions of a second, smaller denominators are slower, not faster. For example, 1/30 of a second is twice as slow as 1/60 of a second.

Let in too much light, and the photo will be washed out and there will be no details—lines on people's faces, letters and numbers on signs, and other fine objects will become blurs. Let in too little light, and your picture will be too dark to see. Photographers call any picture where the shutter has been open too long *overexposed* and any picture where the shutter hasn't been open long enough *underexposed* (**Figures 3.1a, 3.1b, and 3.1c**).

◀ **FIGURE 3.1A:** If you let too much light enter your camera, then your photo will be overexposed.

▲ **FIGURE 3.1B:** Let in too little light and your photo will be underexposed.

▲ **FIGURE 3.1C:** But let in just the right amount of light and you'll end up with a perfectly exposed shot.

There's a connection between the amount of light available and the *shutter speed* (the amount of time that the hole remains uncovered by the shutter). As the amount of light decreases, the time that the shutter needs to be open to get a perfect exposure increases. So as it gets darker, you'll need to have the shutter open for longer periods of time.

There's a pretty simple rule you must follow to get proper exposures: *As the amount of available light decreases by half, the shutter speed needs to get slower by double.*

So, for example, let's say you're taking a photograph outside in daylight at 1/125 of a second and getting great pictures when suddenly a cloud rolls in that blocks exactly half of the available light. You'd need to take the same picture at 1/60 of a second to get the same quality exposure because 1/60 is *twice as long* as 1/125. (Those pesky fractions!)

Most cameras have very specific shutter speeds that date back to the invention of the camera. Camera shutter speeds are usually (from fastest to slowest) 1/8000, 1/4000, 1/2000, 1/1000, 1/500, 1/250, 1/125, 1/60, 1/30, 1/15, 1/8, 1/4, 1/2, 1 second, 2 seconds, and so on.

TIP

Setting your camera to Program mode allows the camera to decide what shutter speed is best for proper exposure.

The shutter speed also has a tremendous effect on the way your photo looks. Think about a person sitting still on a chair. If your camera is set to have the shutter open for 1/15 of a second, your subject will barely move during that time, so in the picture he or she will be sharply in focus.

But if you have that same person ride a bicycle past you, in 1/15 of a second he or she could move pretty far. Let's say the subject could move 10 feet in 1/15 of a second. To the camera, it looks like that bike rider is in all 10 of those feet at once. Light strikes the digital imaging sensor from the bike rider as he or she moves across the frame, so the rider's image will end up being blurred across the photo. To avoid blurriness in a photo with motion, either set your camera to a faster shutter speed (using Shutter Priority mode or a program mode that's designed for sports) or light up the photograph using your flash, or other available light (**Figures 3.2a** and **3.2b**). Using a flash or other bright light allows the camera to use a fast shutter speed.

TIP

At speeds slower than 1/30 of a second, any hand movement while holding the camera begins to cause blur in photos. Add a flash to a slow exposure or put your camera on a tripod.

Now, if shutter speed were all you needed to know about your camera's inner workings, we'd be done. But there's another interrelated component that is just as important as shutter speed.

Before we delve into the next topic, though, let's answer our original questions: The clicking noise you hear when you take a picture is that of the shutter snapping open and closing. The reason you can turn that noise off in some digital cameras is that the mechanical shutters of film photography have been replaced by a digital imaging sensor that only turns on for the length of time of the shutter setting. This happens electronically, so there's no mechanical click. Since people are so used to hearing a click, digital cameras include a prerecorded clicking noise.

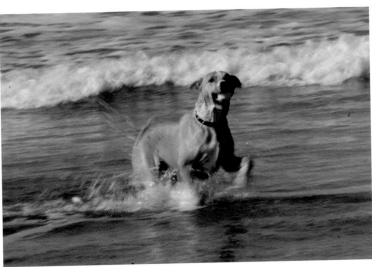

▲ FIGURE 3.2A: If your camera's shutter speed is too slow, then fast-moving subjects will be blurry.

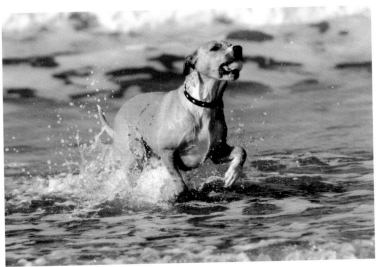

▲ FIGURE 3.2B: To create sharp photos of fast-moving subjects at a distance set your camera to a fast shutter speed.

The Buck F-Stops Here

In case you put the book down for a break, we just discussed how the shutter covers up a hole through which light strikes the digital sensor. Now we're going to talk about the hole that the shutter is covering.

Inside every camera is a small arrangement of overlapping panels that open and close in the shape of a circle. Like a deck of playing cards fanned out and stacked on top of one another, this hole changes shape to allow more or less light into the camera.

This mechanical opening is called the *aperture;* it is also sometimes called an *iris* because it works the same way as the opening in the human eye. The size of the opening is measured using an "f" followed by a number (the "f" stands for *focal length*). This is called an *f-stop.*

TIP

Professional photographers throw around terms like *f-stop* (you pronounce the letter *f* but not the hyphen, so it comes out "eff stop"), *aperture, lens opening,* and so on, when talking about their pictures and how they took them. These terms are simply shorthand to refer to the part of the camera that controls how much light hits the digital sensor.

While the important factor with the shutter is the length of time the opening is uncovered, the crucial thing about aperture is the size of the hole. The hole's diameter controls the *depth of field* in your photograph. The wider the opening, the less depth of field; the smaller the opening, the greater the depth of field.

EYE THINK I GET IT

But what is depth of field? Let's jump back for a second and talk about the human eye some more.

If you look at something near you—this book, for example—your eyes automatically adjust themselves so that only the objects you're looking at are in focus. Switch to looking at a faraway object, and the eye automatically adjusts again, making the distant object instantaneously snap into focus while the nearby things fall into blurriness. Your camera, however, doesn't have these limitations (**Figures 3.3a** and **3.3b**).

In both of these cases, all the objects within a few inches of the subject are in focus, but outside that range they get progressively blurrier. Our eyes have a shallow depth of field, meaning that the portion (depth) of our view (our field) that is in focus is relatively small. (There isn't really a term for the opposite of *shallow depth of field*, but I'm going to call it *deep depth of field*. And then I think I'm going to trademark that and get rich.)

The human brain needs that depth-of-field information to help us move around our world; if everything were in focus all the time, you wouldn't be able to tell where your table ended and your wall began. Your camera doesn't have this limitation, though, and the amount of your photograph that can be in focus at any one time is vast. Most cameras, when equipped with a wide-angle lens, can keep nearly an entire field of view in focus, from a few inches from the lens to infinity.

◀ **FIGURE 3.3A:** When you focus on something nearby, your eyes will automatically adjust to make the background blurry.

▶ **FIGURE 3.3B:** Your camera, however, doesn't have this limitation. If you set the aperture to a high number such as f16, then your camera will keep both foreground and background in focus.

TIP

Cameras usually measure depth of field in inches or feet. Your manual will have a listing for your camera's depth of field.

When you change your camera's aperture, you modify how much of the world it sees as being in focus. With the camera's aperture all the way open, your picture is said to have a *shallow depth of field*. Only objects at the same distance from the camera are in focus. When your camera's aperture is very small, everything from near to infinity is in focus.

Sounds backward, right? It's because this effect is based on a principle of physics. When the aperture is open wide, light rays bounce off the edges of the camera's iris and then strike the digital imaging sensor. Instead of going straight, they are *refracted* by the edge of that opening, and they end up hitting the sensor from an angle. These rays overlap each other on the imaging sensor, and the camera sees multiple images. As a result, the photo looks blurry. Only the object in the center of the image is in focus, because light strikes that point without bouncing off of anything first.

When the iris is more closed, less light enters the camera in general, but the amount of "edge" that the light can refract off of is smaller as well. There's less surface there to scatter the light, so there's less blur.

Bottom line? Depth of field simply indicates how much of what you're looking at is in focus.

A NUMBERS GAME

You've just made it through the part of photography that scares away most people. If you're still reading, pat yourself on the back, go grab an ice cream cone, and then come back.

OK, so there's another slightly confusing thing about aperture, but it's not as bad as what we just went through. You read a little bit ago that the aperture setting is also called the f-stop, but what I didn't tell you was that the *wider* the opening is, the *lower* the number is. So a lens that's really wide open might be set at f/2.8 (pronounced "eff two point eight"), while a lens in which the iris is nearly closed might be set at f/22 ("eff twenty-two").

At this point you must be dying to know *why* the wider opening has a smaller number. Sadly, it's not exciting. The number represents the ratio of the lens focal length to the size of the opening; the bigger the hole, the smaller the number that results when the lens focal length is divided by the aperture size. So much for the "magic of photography"!

F-stop numbers are a bit silly-sounding too. A range of stops from shallow to deep would go f/2.0, f/2.8, f/4, f/5.6, f/8, f/16, f/22. Going from one stop to the next cuts the amount of available light in half, even though it doesn't look that way.

THE INTERCONNECTEDNESS OF ALL THINGS

This is where we put it all together—the big payoff, if you will, to learning about aperture and shutter speed.

When the aperture is very wide open, a lot of light makes its way onto the digital sensor. When the aperture is very small, much less light strikes the sensor. So when you're photographing a dark scene, the aperture needs to open up to let in more light, and vice versa.

▶ FIGURE 3.4: To make sure this shot was in focus, your PhotoCoach had to override the Program mode on his digital camera.

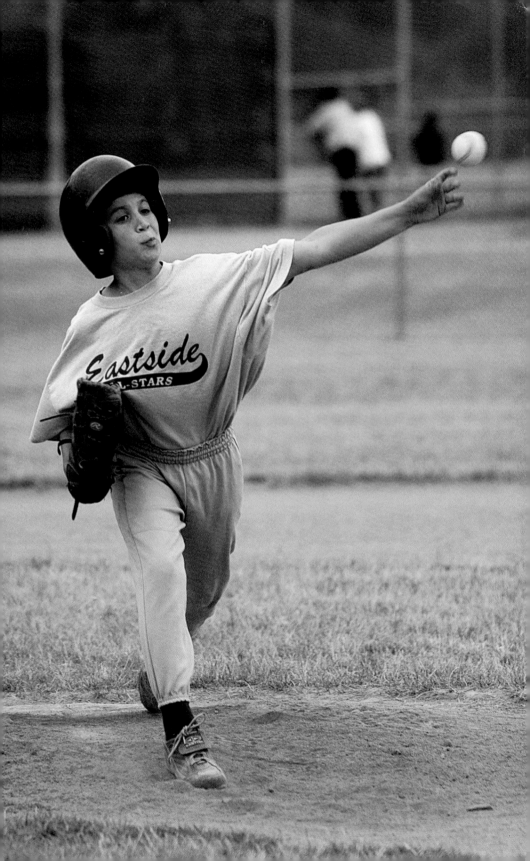

Sounds sort of like shutter speed, right? When the shutter is open for a long time, a lot of light gets in. When the aperture is wide open, a lot of light gets in. Short shutter times mean less light, and the same is true with a smaller aperture setting.

Shutter speed and f-stop are inextricably linked. There's a balance between the two that makes the perfect exposure for the amount of light available. If you decide to change one, you have to change the other one as well.

So imagine we are again out in our field and we're taking a picture. The camera's meter (the device inside it that figures out what that perfect exposure will be) decides that the amount of available light would make for a great photo if the shutter opened for 1/60 of a second at f/16.

Once again our big cloud comes around, and suddenly half of the available light disappears. The camera can decide to take the picture either at 1/30 of a second at f/16 or at 1/60 of a second at f/8. Using a shutter speed of 1/30 of a second would give an exposure that is *twice as long*, while using f/8 would result in an exposure where the aperture was open *twice as wide*. Either way, we will have doubled the amount of light hitting the sensor, to make up for the fact that half of our available light has gone away.

Why do you care about this? Because if you leave your camera on Program mode and let it always decide for you, sometimes you're going to end up with lousy shots. That setting of 1/30 of a second at f/16 won't be a problem if we're photographing a land-scape—mountains don't move that fast, but it's slow enough that a photo of your kid running around at Little League would end up as a colorful blur (**Figure 3.4**).

On the other hand, if you're trying to take a picture of a person standing in front of a distracting background and your cam-

era decides to go with a setting of 1/60 at f/22, your background will be in sharper focus than the background in a shot that was taken at 1/30 at f/16 (**Figures 3.5a** and **3.5b**).

▶ **FIGURE 3.5A:** Often your digital camera will try to keep the background as sharply focused as possible.

▼ **FIGURE 3.5B:** You can, however, change the shutter speed and f-stop settings to make a distracting background unrecognizably blurry.

TIP

The PhotoCoaches usually leave our cameras in *Aperture Priority* mode. That way we can decide how much depth of field we want and let the camera choose the shutter speed for us.

If your camera doesn't have an Aperture Priority mode, you can still use your knowledge of depth of field and shutter speeds to your advantage. Most cameras come with *preset scene* modes (though some cameras call them other things) that change multiple settings on the camera at the push of a button.

A *Sports* preset tells the camera to prioritize on a fast shutter speed over a slow one. A *Landscape* preset selects a deep depth of field (wide aperture setting) over a fast shutter speed. A *Portrait* mode picks a setting that'll keep the foreground sharp and blur the background. A *Macro* setting works like a portrait setting but tells the camera to focus as close as it can.

Selecting your own aperture, shutter speed, and presets is the most powerful lesson you can learn from your PhotoCoach. Of course it's fine to let the camera make the decisions for you, too, but for the ultimate in creative control, take charge of your camera.

Sensitivity

Here's another cool way that digital beats film: You can change the sensitivity of your camera from shot to shot. I'm not talking about how emotional your photographs are, but about the way the camera responds to light.

Unlike digital photography, film photography is based on chemicals that react to light striking them at a certain speed, and that speed represents the film's sensitivity to light. Let's imagine that a dot of chemical can carry out its little color-changing

dance on a piece of film in 1 second, while another type of film takes 2 seconds for the same thing to happen.

The film that takes 2 seconds to transform would be half as sensitive to light as the one that takes 1 second. This can't be changed from frame to frame because each roll is uniformly sensitive (because it's all made with the same chemical composition). This is why you'll see film sold in stores that is outdoor or indoor film—different locations have different kinds of lighting. Film designed for outdoor use is less sensitive to light than that for indoor shooting, because there is less light inside than under the sun (generally speaking).

This sensitivity is called the film's *speed* and is referred to by a number assigned by a group called the International Standards Organization (ISO); any film certified with a certain number is assured to match the sensitivity of any other film with that number. The higher the number, the more sensitive the film, and like f-stops and shutter speeds, each number doubles the sensitivity. ISO 50 is half the speed of ISO 100, and so on (**Figures 3.6a** and **3.6b**).

TIP

When we're shooting sports or other scenes with fast action, though, we switch to *Shutter Priority* mode to ensure that our shots have the amount of sharpness or blur that we want.

◀ **FIGURE 3.6A:** These hummingbirds were photographed with a standard ISO setting of 100. The blurriness is due to camera shake caused by a long exposure.

▼ **FIGURE 3.6B:** This photo was taken at the same shutter speed and f-stop as the other one, but this time the ISO was bumped up to 400 to eliminate the camera shake.

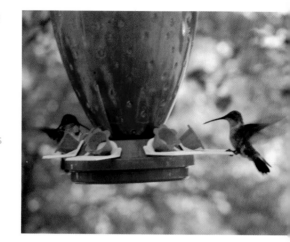

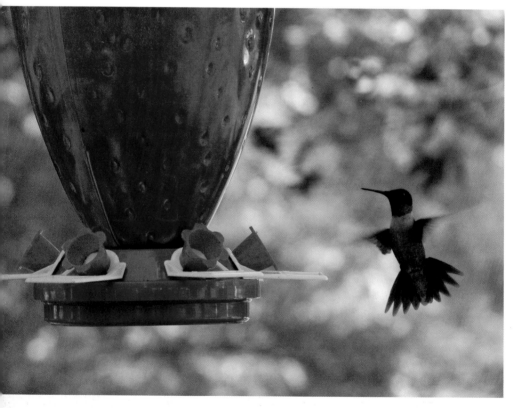

A digital sensor can change its ability to record light with each shot, making it more or less sensitive to light.

The higher the sensitivity, however, the more *noise* in the image. Stray pixels and dots are more likely to show up at ISO 400 than at ISO 100 because the camera is four times more sensitive to stray bits of light. Reflections off the lens, static electricity buildup, and other things can all get recorded as stray bits of colors.

So there's the inevitable tradeoff: A higher ISO speed will capture fast-moving subjects faster at the same shutter speed and f-stop, but the resulting image may have more noise (**Figure 3.7**).

▼ FIGURE 3.7: You may need to increase your camera's ISO speed to capture images in low light conditions or to capture images of fast-moving subjects. Higher ISO speeds, however, cause photos to have more noise.

Here's how it would work in real life. Let's say you have the ISO set to 100, and in order for the camera to produce a properly exposed photo, the shutter speed needs to be set to 1/125 and the f-stop to f/16. If you change the ISO to 200, you are doubling the digital sensor's light sensitivity so you'll need to change the shutter speed and f-stop to be half of the previous setting—either by going to 1/250 at f/16 or 1/125 at f/22 in order to capture a properly exposed image.

TIP

Speeds between ISO 100 and 400 generally have very little noise, even in digital cameras, but the lower you can keep the ISO and still get the picture you want, the better.

Digital cameras trump film models in the way they enable you to change your camera's sensitivity from shot to shot, instead of from roll to roll. Check your camera's menu to see what ISO speed you're shooting at. Most cameras will choose the lowest setting, as it's the one that provides the highest quality image.

Changing the sensitivity setting will enable you to capture pictures in low-light situations or take a faster shot of something in the same lighting. It also will allow you to capture images that you'd otherwise miss, such as high-speed sports, low-light portraits, and long-exposure night shots (**Figures 3.8a, 3.8b, and 3.8c**).

◀ FIGURE 3.8A: Changing your camera's light sensitivity to a higher setting can help you capture sharp action shots.

Get the Balance Right

For those of us not old enough to remember, photographs used to be only black and white. Not out of preference, mind you—pictures were black and white because that was the best the technology could muster.

Accurate color rendition has been the goal of photography ever since, and even though nearly a hundred years of history passed between the first photographic image and the first color image, capturing colors on film (and then later digitally) was always the aim. Heck, even popular culture recognized the photographer's craving for colors that looked like those in the real world, immortalized in Paul Simon's song "Kodachrome."

Getting colors to show up on film accurately is an amazing trick involving several layers of light-sensitive chemicals, separated from one another by thin membranes. As light strikes the

▼ FIGURE 3.8B: You can use the same trick of increasing your camera's light sensitivity to take photos in low-light situations.

▲ **FIGURE 3.8C:** At the highest ISO settings, you can even take great photos at night.

chemicals, they react to different colors in different ways, and form the basis of the photographs we see.

The exact method of achieving exposures has been tweaked over the years, and color film is now very competent at reproducing the world around us. Usually.

Color film has an important limitation that digital photography does not—colors on film are only accurate in the lighting conditions the film was designed for. Every "white" light source (the sun, flashlights, your camera's flash, fluorescents) has a slightly different color that the human brain automatically adjusts for. It all looks just plain white to us.

Color film is said to be "balanced" for a particular type of light—"daylight"-balanced" film is designed so that light coming from the sun looks white, while "indoor" or "tungsten"-balanced film is tweaked so that the yellowish color coming off the light

bulb looks white. The digital image sensor in your camera sees things a different way because it's very different from a piece of film. Across the imaging sensor is an array of dots. Each dot records the amount of light striking it. The sensor doesn't care what color of light is coming into the camera, as long as it *knows* what that color is.

Many digital cameras just take the approach of guessing, and most of the time that works out fine. The chips that control your camera's metering system think about the incoming light and then look for an area of the image they think is white; they then use light bouncing off of that object to set the *white point*.

The problem with this is that there sometimes isn't anything white in a photograph, and when that happens, the whole picture ends up the wrong color.

▶ **FIGURE 3.9A:** Sometimes your camera makes a wrong guess about what constitutes "white" and throws the whole color of your photo off.

▶ **FIGURE 3.9B:** You can, however, tell your camera what sort of light is being used in the scene and it will compensate for it.

▲ FIGURE 3.9C: Alternately, there may be times when you want to change the white balance setting to something that is deliberately wrong. In this image, the photographer purposely set the white balance to daylight in order to make the evening sky more blue and the light fixture more yellow.

Picking through your camera's menus, though, you should find the solution to this color conundrum, the *white balance* setting. White balance settings are usually named after the type of light you'd use them for: tungsten, daylight, flash, and so on. Many times, however, these settings are represented by an icon instead of a name. By selecting a white balance for your photo, you'll be sure to end up with a perfect set of colors (**Figures 3.9a, 3.9b,** and **3.9c**).

You can also use white balance settings to change the tone of a photo. For example, when the 'Coaches want to enhance the look of a photo, we'll often change the white balance. Shooting a sunset in Shade mode adds warmth (yellows, oranges, reds) to a photo while shooting daylight scenes in Tungsten mode produces a winter-like blue (**Figures 3.10a, 3.10b,** and **3.10c**).

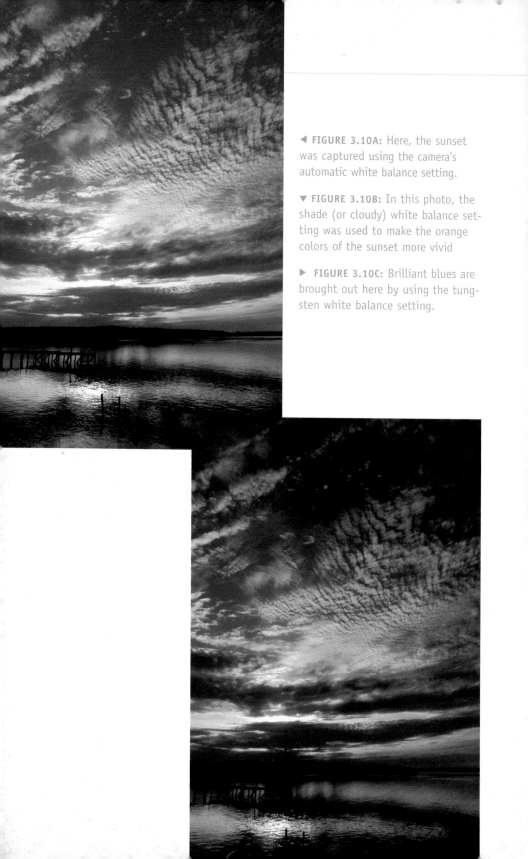

◀ **FIGURE 3.10A:** Here, the sunset was captured using the camera's automatic white balance setting.

▼ **FIGURE 3.10B:** In this photo, the shade (or cloudy) white balance setting was used to make the orange colors of the sunset more vivid

▶ **FIGURE 3.10C:** Brilliant blues are brought out here by using the tungsten white balance setting.

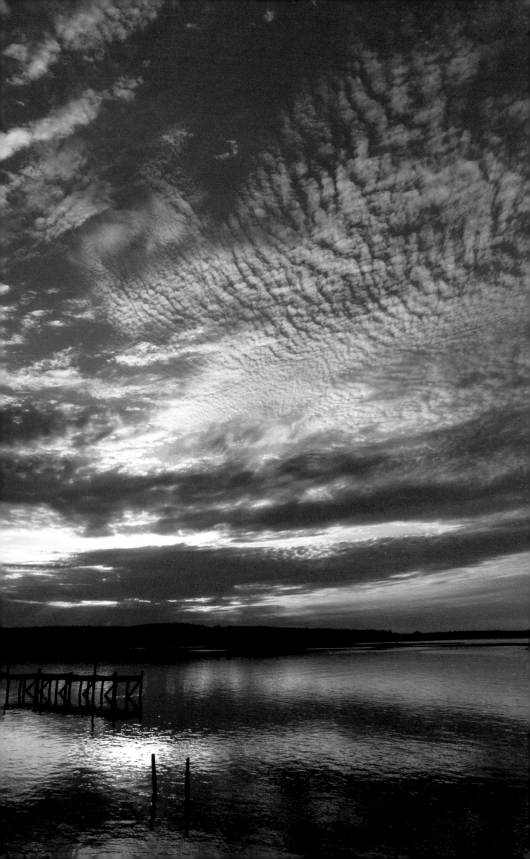

My Brain Hurts

Even veteran photographers get confused by these topics some-
times and wind up with a dull, throbbing headache. The fact that
shutter speed, aperture, and sensitivity are all connected can be
terribly confusing. The most important thing to remember is
that they are all *directly* related, so that when one of them
changes, something else has to change as well to keep the balance
right.

If you set the sensitivity first to match the lighting situation,
you can then forget all about it until the next time you need to
change that setting. It's a good idea to always leave your camera
at the lowest ISO setting unless you have some specific need to
change it (low light without a flash, for example), as you'll get
the highest quality picture that way.

Shutter speed and aperture are your main considerations, and
their relationship is pretty simple once you've gotten through all
the concepts we just talked about. When one goes up, the other
goes down. If one goes up by two, the other one has to go down
by two. That's it.

Most cameras have automatic modes that handle all these
details for you, but by mastering the principles of white balance,
shutter speed, and aperture, you can take better, more creative
photographs (**Figure 3.11**). And that's what it's all about.

▶ FIGURE 3.11: There's no limit to the photographs you can take if you
use your imagination and the right camera settings.

The Olympic Difference
Experimenting with shutter speed can pay off

Understanding the effects of shutter speed helped Kevin Gilbert relieve the monotony of a grueling shooting schedule at the 2000 Summer Olympics in Sydney, Australia, where he was shooting for the newswire service Agence France-Presse (AFP). "AFP asked me if I wanted to shoot the USA basketball team at the Olympics—the Dream Team," Gilbert recalls. "So I looked at the schedule, and I saw that they played eight games. Sounded like a great assignment to me—eight games, a free trip to Sydney, no problem."

When he arrived in Australia, a meeting with his AFP editors was first on the agenda. "They handed me a list and said, 'Here's your schedule,'" Gilbert says. "They had me shooting 78 games in 16 days. Every game—men's, women's, consolation, you name it. I was shooting from 9 a.m. until 11 p.m. every day with maybe 15-minute breaks between games. I went to the Olympics and never left the basketball arena.

"It was fun for a few days, but after a number of games I started thinking, what can I do that's different? I was bored more than anything else. So I started experimenting with slow shutter speeds—1/15 of a second, 1/30 of a second—and panning with the moving players." Standard sports photos are always done at fast shutter speeds to freeze the action and make everything sharp. "I was there to do a job, so I did those kinds of pictures for most of the game," Gilbert says, "but I started playing around with the slower shutter speeds in the third quarter of every game.

"And I liked what I was getting—the motion, the wash of color, the background blur. I liked it, but AFP wouldn't run any of them on

the wire. I would get these little notes from the editors that said, 'Yeah, I see you had your camera set wrong in the third quarter.'"

After nearly two weeks of shooting, the gold medal round arrived, and much to Gilbert's surprise, the photographers were allowed to shoot from the arena's overhead rafters. "That's not done in the U.S.," Gilbert explains, "but the Sydney people allowed us to stand up there and shoot. So I went up there in the third quarter of one game and played around with slow shutter speeds some more, panning with the players from overhead.

> "I shot this guy at 1/15 of a second with a 300 mm lens, so he's flying through a field of blue going for this dunk, and I loved the shot."

"At one point while I was up there an American player went flying down the lane for a monster dunk," says Gilbert. The lane, the swath of the floor that extends about 15 feet out from the basket, was painted blue. Gilbert continues, "I shot this guy at 1/15 of a second with a 300 mm lens, so he's flying through a field of blue going for this dunk, and I loved the shot. When I sent my pictures in, I told the editors that I had a great shot." Still, they wouldn't put it out on the wire. Standard fast shutter speed shots of the play taken from courtside got published instead.

"But later," Gilbert says, "AFP put out a coffee-table book of photos from the Sydney games, and they did use it for that. To this day, it's probably my favorite sports picture I've ever taken."—EAMON HICKEY

How to Use
Your Flash

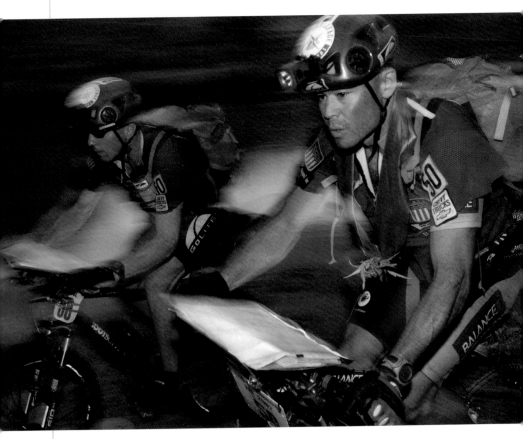

How to Use the Little Square Strobe in Your Camera

to Make Everything Look Better

IF IT WEREN'T FOR THE SUN, a lot of things would be different on the planet. Ignoring the point that life wouldn't have sprung up at all without the warming rays of our nearby star, things here would be very dark. We'd all walk around with flashlights, squinting our eyes trying to figure out *where exactly did I leave the box of cereal?* while we stubbed our toes on things left lying on the floor. It would be a very strange place indeed.

But more important, our photos would look horrible. Every shot would look like the previous one—a big black square of nothing. "This is a picture of my Aunt Gladys," you'd say, holding up a big black print, "in her house in Maine" while people rolled their eyes (you wouldn't be able to tell) and yawned in boredom.

So it's lucky for photographers that we have a blazing ball of fire perched a few planets down the street. The sun provides brilliant illumination for our photographs. It turns long fields of grass into stunning vistas, sunrises into virtual fireworks, and the smile on a child's face into a work of art.

Sure, you've got me on a technicality—the sun's not out at night. And what's more, there are some places we take pictures where the "sun don't shine," to borrow a phrase. You're exactly right, which is why it's so very important to understand how to use your camera's flash to make every picture look like it's lit by the rays of the sun (**Figures 4.1a** and **4.1b**).

◄ **FIGURE 4.1A:** Sometimes the sun doesn't provide enough illumination, or it provides it from the wrong angle.

▼ **FIGURE 4.1B:** That's when knowing how to use the flash on your camera will help you make your photos better.

You Light Up My Life (Because Everything Written About Flash Needs to Use That Pun)

Modern photographers have a lot to be thankful for (digital cameras, nifty color printers, tack-sharp lenses, and this book), but one of the most-often-taken-for-granted wonders is a camera's flash. The name comes, of course, from the burst of light needed to illuminate a scene, and from the fact that the original flashes were simply trays full of a combustible powder. A photographer would open the camera's shutter, light the powder, wait for the flash, and then close the shutter.

Nowadays a camera's flash is an electronically charged little powerhouse, turning electricity from the camera's battery into a light source that can bring a dark scene to life. Even the smallest point-and-shoot camera provides a flash that outclasses the burst of flame that photographers once used.

While the technology used to make a modern flash (also called *strobe* due to the quick pulsing nature of some units) has come a long way, most cameras aren't too smart about deploying it. Cameras will fire a flash anytime available light gets a bit low. As a result some photos are terribly over-lit by a flash, while some pictures are darker than tar on a hot road in July.

TIP

Available light, sometimes also called *ambient light*, is a term used to describe the amount of light falling on a scene without its being lit up. There is more available light outside at high noon than at dusk, for example. A famous studio photographer once told a crowd at a conference, "I only believe in shooting with *available light*." Everyone in the audience gasped. He paused and then said, "By which I mean, any darn light that's available."

Another problem with strobes is that the light quality that comes from them is often harsh and glaring. If your photographs look more like police lineups than portraits, you might be suffering from the effects of the camera's flash. And, of course, there's the flash "biggie"—red-eye.

What the Heck Causes Red-Eye, and How Do I Stop It?

We've all seen it, we all hate it—red-eye is the scourge of photography. But the glowing red eyeball effect that is the hallmark of so many bad photos is caused by a cool bit of biology.

When light is low, the eye's pupil opens up to let in more light. This low-light condition is the same one that causes your camera to set off a flash. Light from the flash travels in a straight line to the eyeball, where it enters the wide-open pupil, hits the back of the eyeball, and reflects off all the neat-but-yucky stuff back there. The light, now tinted by the red blood in the vessels of the eyeball (I told you this was cool) travels back to the camera, where the redness is captured.

There are two ways to overcome red-eye. The first is to use a flash that's not so close to the lens. As the distance between the lens and the flash gets greater, the angle of the light entering the eyeball changes, and that causes the light from the back of the eye to reflect away from the camera.

The second method doesn't work as well, but it's the only solution for a camera that can't use an accessory strobe. Operating in red-eye reduction mode (see "Flash Modes: More Than Meets the (Red) Eye," below), the camera flashes multiple times very quickly and then emits one longer flash. The several quick bursts of light make your subject's pupils contract, which allows less light to enter or exit, and reduces the amount of red-eye.

The key to flash photography overall is being smarter than your camera. Let the PhotoCoach show you the tricks to knowing when to turn the flash off, when to turn it on, and how to modify the light in order to take better pictures than ever.

Seeing the Light (in a Different Light)

To better understand the limitations of flash photography, let's talk about astrophysics for a moment. Don't put the book down in fear—it's nothing complicated, but it will make it easier to understand camera lighting, and it might make you sound cool at a party some day. (It hasn't worked for the 'Coach, but I'm still trying.) It is so simple that we can sum up all the rules involved in a simple list.

- The sun is very, very, very big. Relative to the size of the sun, the earth is very, very small.

- The sun is very, very, very far away.

- On its way through the atmosphere from the sun, light gets bounced around by water and other stuff that floats in the air.

- The light that hits your camera has come from a very big object, very far away, and is very diffused. A diffuse light source is said by photographers to be *soft,* meaning that it evenly illuminates a subject without causing harsh shadows.

- Light at certain times of the day is softer than at other times. During the early morning and just before twilight photographers find the softest lighting, whereas the light from overhead at noon is much more harsh.

A light's quality, its hardness or softness, is determined by some key factors, including the size of the light source and its distance from the subject. Distance from the camera's lens is also important to factor in, as that angle affects the overall look of the picture as well.

The sun is very wide, and very far away. A strobe by comparison is a very teeny object that's perched right next to the camera's lens. It's the small size of the flash and the closeness to the subject that makes flash lighting so harsh (**Figure 4.2a**). Professional photographers use all sorts of expensive gear that can be set up anywhere in a room and all types of nifty accessories to make that light more diffused (**Figure 4.2b**).

◀ **FIGURE 4.2A:** A camera's built-in strobe can produce harsh lighting.

▼ **FIGURE 4.2B:** Accessory strobes, however, can often provide softer, more natural lighting.

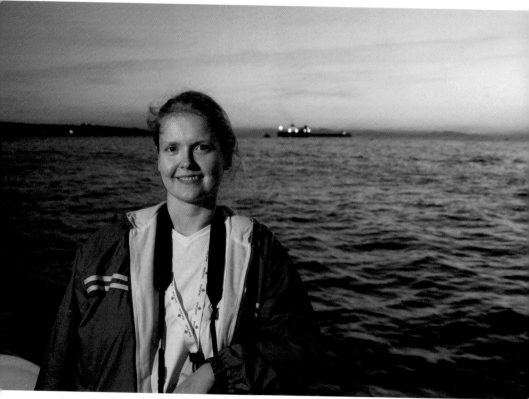

Anytime available light drops below a certain level, your camera's strobe fires. Unless you tell it otherwise, the strobe fires at a very powerful setting, often enough to overexpose your picture.

At speeds slower than 1/30 of a second, the camera usually begins flashing away. That's because the camera assumes that if you need to take such a long exposure, then the light must be low. But the long exposure that should compensate for that low light will cause the picture to be blurry because of either camera shake or subject movement. The camera has no way to tell that you're taking a picture of a still life using a tripod instead of trying to capture a baseball player while standing on your seat in a stadium. Flash. Flash. Flash.

The PhotoCoach has a few tricks up his sleeve to get around this problem, depending on your camera model.

Almost all cameras have a way for the user to turn the flash on and off, overriding the camera's decision that a strobe is needed. There's a magic button that controls the flash. Cleverly disguised as a lighting bolt, this button changes your camera's settings (rather than projecting an actual bolt of lighting). On cameras that are menu driven, flash control is often found in the menus with the same symbol (**Figure 4.3**).

▶ **FIGURE 4.3:** Some cameras do not include button controls for the flash. With these, you'll need to access the menus to control the flash.

TIP

The flash button might be the most important one on your camera, aside from the shutter release. With it you can tell your camera to turn the flash on or off, at your will, drastically changing the look of your pictures.

Perhaps the thing the PhotoCoach does most often with his camera is turn off the flash in low-light situations. Often a dim room or sunset will have a nice yellow glow to it, something that really can add to the warmth of a photograph. The light of a camera's flash is balanced to look like daylight, so the end result is a picture without any of the subtle lighting or interesting warmth of the actual scene (**Figures 4.4a** and **4.4b**). By telling the camera to turn off the flash, you can get your photograph to have the warm look you wanted in the first place. You'll need to hold the camera extra steadily or use a tripod in some scenes, but that's a small price to pay for a photograph that looks great.

There are other advantages to turning off the flash as well. For example, a flash uses a lot of power, so whenever your camera needs to take a flash photo, it takes a few seconds to gather up the energy from the battery to provide sufficient light. Turning off the flash lets you take a picture on the spur of the moment without waiting around.

TIP

Kids and pets are really hard to photograph using a flash. The light is distracting and usually is startling enough to make them stop doing whatever cute thing you wanted to photograph in the first place. By shutting off the flash you can get multiple shots without their even realizing they are being pho-tographed. This way you can let sleeping dogs lie, and *still* have a great photo of them.

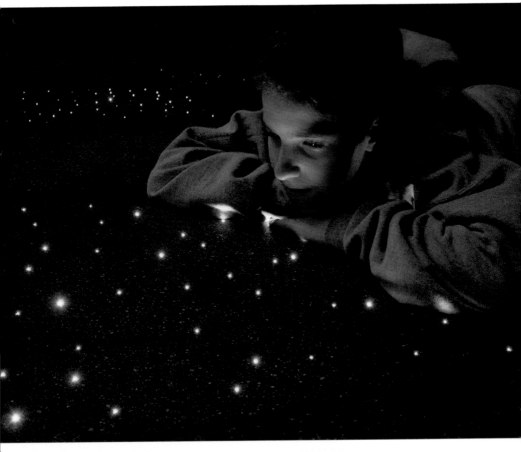

▲ **FIGURE 4.4A:** By keeping the camera's flash turned off, the photographer was able to capture the magic of the scene.

◄ **FIGURE 4.4B:** With the flash turned on, the scene loses all of its meaning.

Flash Modes: More Than Meets the (Red) Eye

Now that you know where the flash button is, you'll be able to unlock the power hidden in your camera's flash. Most digital cameras offer a variety of flash modes, only a few of which mere mortals ever use. But you're turning into a photographic expert, so here's an explanation of what you can find under your camera's hood.

TIP

Not all cameras have all these modes. You can select flash modes via an on-camera button or through your camera's menus depending on the model.

- **Automatic**. This is the main setting. The camera decides when flash is needed, and it goes off automatically. Use Automatic when you need to take shots without thinking about lighting levels.

- **Red-Eye Reduction**. Selecting this mode causes the strobe to send out several short bursts of light followed by a longer flash. This constricts the pupils in your subject's eyes and can help lessen red-eye.

- **Flash-On**. Also called *Fill Flash*, this setting tells the camera to fire the flash even when there is plenty of ambient light. Why would you want to do this? Check out "Fill in the Blanks," below.

- **Flash-Off**. The PhotoCoach's personal favorite, this shuts off the flash.

- **Slow Sync.** Usually only found on accessory strobes, Slow Sync is great to use at night. With it, the camera starts off taking a long exposure and then fires the strobe to give the scene a little more kick. This is great for creating special effects (see Chapter 11).

Fill in the Blanks

Now that we've covered the idea of turning off the flash to preserve a photographic mood, let's talk a bit about turning *on* the flash to enhance an otherwise weak photograph.

When we were talking about astrophysics to understand lighting, I mentioned that the light from the sun looks better at some times than at others. There are some situations where there is plenty of available light, but the *quality* of the light is just terrible.

Take the picture shown in **Figure 4.5,** for example, and see if you can tell what's wrong. It's pretty clear that the subject looks just dreadful with shadows under his eyes and across his face. There's lots of light in the scene—it's just all in the wrong places. That's because a camera can't tell if someone looks good or bad in a photograph; it can only tell if the picture is properly exposed. Even though there are shadows on the face, the overall picture looks just fine to the light meter.

This is when it's a good idea to turn on the flash. Even though it's less powerful than the sun, using your flash in combination with ambient light helps to illuminate problem shadow areas and make for a great picture (**Figure 4.6**).

Some cameras have a Fill-Flash mode or a Flash-Exposure mode that allows you to set the output of the flash to less than full power, which really helps to make a picture *pop* without overpowering the soft light from the sun.

◀ **FIGURE 4.5:**
Without using a
flash, this man's
face becomes
buried in shadows.

▼ **FIGURE 4.6:**
But simply turn on
the flash and voilà!
You get a much
better photo.

Cameras these days use sophisticated light meters that look at a scene and figure out the proper exposure. These meters usually pay more attention to the exposure right in the middle of the frame, but they also look at all the other segments of the frame as well.

If your subject is off-center, though, the camera will assume that whatever is in the middle is the most important thing to capture. To get better exposure on your subject without using your flash, make sure it is centered in your viewfinder as you partially depress the shutter release button. While continuing to hold the shutter release button, move the camera to set up the composition you like. This will take a light meter reading with the priority on your subject.

Why Is His Head Lit Up but the Background Is Dark?

Camera strobes have another limitation—they are only powerful enough to light up a relatively small area in front of the camera. There's no way that a built-in strobe can light up a really large room or a whole outdoor scene. Light only travels so far in 1/250 of a second, so the output from that little flash unit has a lot of ground to cover. It's also hard for the flash to crank up enough power to get very far. To double the distance light will travel, you need to square the power. There's only so much that the little batteries inside a camera can manage before there's no juice left to take a picture.

Nearly all digital SLR cameras and some point-and-shoot digital cameras have a mounting bracket on the top that accepts an off-camera flash unit. Much more powerful, and more config-

urable than the built-in strobes in cameras, accessory flash units aren't so prone to the problems inherent in the little units inside your camera.

First of all, the off-camera flashes are considerably larger than the one built into your camera (remember the size of the strobe is related to the softness of its light) and sit much higher up from the lens (so they are less prone to producing red-eye). Second, since they are driven by their own set of batteries, these strobes are more powerful, meaning that they can send light a greater distance.

Finally, with more space to dedicate to the electronics of the flash itself, the units are more adjustable. Accessory flash units often have settings to control power output, can auto-sense the lenses attached to a digital SLR, and have processors that talk to the camera and help calculate perfect flash duration times—all of which means better pictures. Some units even work wirelessly so that they can be placed around a subject and triggered without a cable and without being connected to a camera.

Many strobes have attachments to modify the light coming from them—add-on systems that can host gels or reflective surfaces that help soften or modify light to make a perfect shot (**Figure 4.7**). Bouncers, well, bounce light to soften it , while soft boxes diffuse light. Both bouncers and soft boxes come in all shapes and sizes, but you can get small, lightweight ones that will easily fit in your camera bag. Even more portable are snap-on flash diffusers, which are often called *diffuser domes*.

No matter what strobe options are available for your camera, understanding how to control them can make you a better photographer in no time, and will help to really (sorry for this) brighten your photography.

◀ **FIGURE 4.7:** You can get add-ons for your flash to modify how the light works. From top to bottom are a bouncer, a portable bouncer, a snap on diffuser dome, and a soft box.

Solving the Sun Puzzle
Using flash outdoors to eliminate shadow

The advice to turn off your flash indoors and turn it on outdoors seems strange, but outdoor fill flash served Nick Didlick well one day in 1988 in the Middle Eastern country of Oman. England's Prince Charles and the late Princess Diana had stopped there during an international tour. Didlick and a colleague were covering the couple for the Reuters news service.

"Prince Charles was playing in a polo match," Didlick recalls, "and the rumor was that he would give her a kiss at the end of the match. This was supposed to be a major story because it was culturally inappropriate. Oman was a very conservative country.

"There were probably 30 photographers and five TV crews following Charles and Di around, and everybody lined up in the same place to get the kiss." As is usual, the photographers were restricted to certain designated areas. "They thought they had the best angle," Didlick continues, "but I looked at this and saw that my buddy [the other

> "There were probably 30 photographers and five TV crews following Charles and Di around, and everybody lined up in the same place to get the kiss."

Reuters photographer] had a good position with all the others, so I took the opposite angle."

The problem with Didlick's spot was that it put the bright sun behind the royal couple, leaving their faces in shadow when viewed from his angle. "I thought that if the kiss went my way, I'd have a bet-

ter picture, but it would be a silhouette. So I had to pull out
a flash unit and try to fill in. I stuck the flash on my camera,
made one test flash, and waited. The match ended. Princess Di
presented the trophy. There was an awkward pause, then he
leaned forward and kissed her, and I had my picture. It fronted
nearly every British newspaper the next day."

Didlick smiles at one more recollection. "One common
trick in Britain at the time: The photo editors ran my picture
with their own staff photographers' bylines—all those guys
who'd taken the wrong angle." —EAMON HICKEY

The Twilight Zone
Lighting up faces at night

Rob Galbraith blended flash with twilight to make a standout picture during Eco-Challenge New Zealand in 2001. Galbraith was part of the Blue Pixel crew photographing the adventure race for Eco-Challenge Productions as well as for the TV broadcasters USA Network and Discovery Canada, among others. Galbraith had been assigned one day to shoot a section of the course where teams had to cross a river. He spent many hours there photographing racers as they passed through.

As night fell, he got an idea for a shot he thought would look interesting. "There was fog and low-hanging clouds in the mountains in the background, and it was that time of day beyond twilight but not quite dark," he says. He wanted to photograph a racer with the rich blue sky of twilight in the background. Capturing the sky at dusk would require a long shutter speed—about 1 full second.

"There was fog and low-hanging clouds in the mountains in the background, and it was that time of day beyond twilight but not quite dark."

The racers, conversely, would have to be lit by flash, and Galbraith had visualized how he wanted that to look. "I really liked the idea of the subject heading into the light," he says, "where you have faces well lit but lots of deep shadows."

To accomplish the shot, he attached a flash to a small tabletop tripod and placed it on the riverbank that contestants would be heading toward. He put a second flash on his camera's hot shoe to provide more even light, like that found in a studio. The flash on the river-

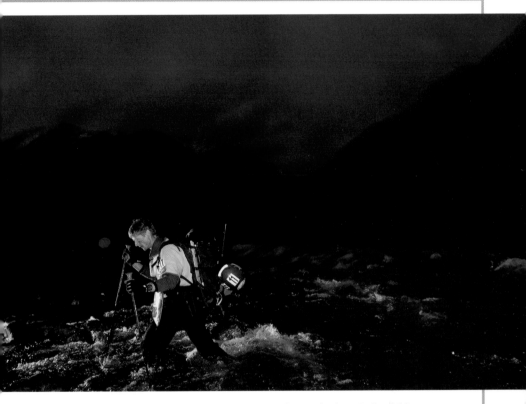

bank would be fired by a radio remote control attached to Galbraith's camera. He relied on his experience to set the remote flash's power output manually.

When he saw a racer from Team Subaru Canada approaching, he waded into the water and waited in the middle of the river. He had placed himself and his tripod-mounted flash according to his observation of where previous teams had tended to cross the river. But, he says, "partly it was serendipity that the guy crossed where he did. These things are always 50 percent planning and 50 percent dumb luck. As he picked his way across the river, I simply shot a series of about ten shots." —Eamon Hickey

How to Download and Organize Your Photos

(Before You Have to Buy

a New Memory Card)

'COACH REMEMBERS THE DAYS of film photography all too well. After an important photographic assignment I'd head over to the processing lab, where I'd turn over my precious film, and then wait anxiously for it to come back. From the moment I pushed the shutter release button until the second the pictures were in my hand, I would be a bundle of nerves—without that film there was no way to tell if the job had gone well.

Even worse, sometimes someone would make a mistake—the wrong chemical would be used or some other processing error would ruin a batch of film. That was heartbreaking. Digital photography has changed all that, and your PhotoCoach thanks his lucky stars that taking pictures no longer involves long (and expensive) trips to the photo lab. Instead, each photo shoot comes with instantaneous feedback and the secure feeling that comes with knowing that nothing can go wrong in a darkroom to ruin a roll of film.

On the other hand, anyone who has used a digital camera knows how easy it is to take an overwhelming number of pictures. It used to be that people would take a few rolls of film on a vacation; now they come back with hundreds and hundreds of photographs. Instead of taking a few pictures at a birthday party, digital camera users shoot dozens.

The act of transferring the pictures from your camera to your computer has replaced the trip to the photo lab. This process can take up almost as much time as driving to the photo lab, but seeing the results is faster than waiting for film to get developed. Digital does, however, introduce a couple of problems you don't encounter with film. With the number of pictures you're likely to take with your digital camera, the photo you take today might be nearly impossible to find on your computer years from now. Even worse, a computer hard-drive crash could wipe out a lifetime of priceless photographs in a single *bbzzzttttt-clunk*.

Freaking out? Take a deep breath and relax. There are easy ways to make sure that digital photographs are as easy to manage as they are to take. It just requires some planning and a few tips from your PhotoCoach.

TIP

Professional photographers often talk about *workflow*. It's a silly and scary term that means "how I handle photographs after I take them." I hate the term myself—who the heck wants their photography to include work of any kind, and who wants it to flow anywhere?

Film has workflows, too, usually limited to taking your film to the lab, getting your photos back, and putting them in a box. Digital photography requires a more complex process but saves you from having to dig through a box full of pictures to find the perfect shot.

Transfer Student

Every camera's instruction manual says the same thing: Plug one end of the (included) USB cable into a port on the camera, plug the other end into a port on your computer, and transfer your images using the included software tool.

Don't you dare!

With very few exceptions, digital cameras transfer data using a USB 1.1 connector, which is found on just about every computer made in the last five years. USB 1.1 is painfully slow—so slow, in fact, that more-modern computers have USB 2.0 connectors that operate many times faster when connected to devices that are designed to handle the faster speed. Older USB 1.1 devices can plug into USB 2.0 ports and will work at the older, poky speeds.

TIP

USB 1.1 operates at 12 megabits per second (Mbps), and USB 2.0 operates at 480 Mbps. You don't need to know what that means exactly, but the bottom line is that USB 2.0 is 40 times faster than USB 1.1. Another connector found on some computers, called FireWire, moves information at 400 Mbps, making it nearly as fast as USB 2.0.

So the problem with using the camera's USB 1.1 connector is that it's painfully slow (**Figure 5.1**). Fortunately many companies make external card readers that take advantage of the speeds of USB 2.0 or FireWire to help speed image transfers along (see Chapter 12). With these card readers, you simply take the media card out of your camera and pop it into the external card reader, and instantly you've made the transfer process 40 times faster (**Figure 5.2**).

Think of all the time you'll save with that one tip alone. I could stop writing now and you'd *still* get your money's worth out of this book.

Want another reason to use an external card reader? Transferring images directly from your camera uses up the battery, while external card readers pull their power from the computer itself. Now I've saved you time *and* money in the space of three paragraphs!

◀ **FIGURE 5.1:** Don't do it! Most cameras use a sloooow USB 1.1 connector to transfer images directly to your computer.

▼ **FIGURE 5.2:** It's money well-spent to purchase an external card reader that supports extremely fast image transfers from your camera's media card to your computer.

Moving Right Along

Now that you've improved your photo-transfer speeds, let's talk about where your photographs are going. When you drop that card into your external reader, both Macs and PCs will recognize it right away, and the files will appear on the computer's desktop. Usually the card will show up with a name similar to the name of your camera or reader, and it will contain a folder with your images (**Figure 5.3**).

▼ **FIGURE 5.3:** Here's what you'll see when you open up a camera's media card on your PC. These images were taken in JPEG format, which is denoted by the .JPG extension. Most cameras also let you take pictures in the camera's RAW format.

Here's where you get to make a choice: You can either manually copy the pictures from your card or use the software that came with your camera or computer to move the files to your hard drive.

Before you move anything from your card to your computer, though, let's stop a second and talk a bit about some really important issues. Digital cameras create files that are incredibly hard to tell apart, with names like DSC0350.JPG. I don't know about you, but there's no way that I could tell DSC0495.JPG apart from DSC1345.JPG.

What you want to do is find a way to be able to go back to your computer years from now and pick out exactly the file you need, without opening up each and every picture on your system. There are a few approaches to doing this.

The Simple Approach

One way to manage your photos is to use software such as Apple's iPhoto for the Mac or Adobe Photoshop Album for Windows PCs. These programs take all the work out of naming and organizing your images, allowing you to find things by date, keywords, or other criteria. Both of these programs let you create albums of selected images, share pictures with other people, create Web pages, and back up your images (**Figures 5.4a** and **5.4b**).

What they don't do, though, is allow you to move things around on your computer without a headache. Once you import your pictures using these programs, they are placed in folders that make sense to the software. In order to share your pictures, for example, you need to open up the program and click the Sharing button. It's very difficult to just find the file in a folder and email it to someone without using the application.

▶ **FIGURE 5.4A:**
Programs such as
the popular Adobe
Photoshop Album
help you organize,
name, and manage
your photos easily
on a Windows PC.

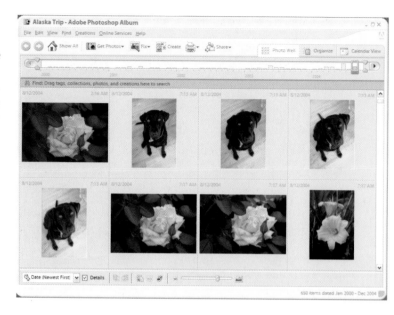

▶ **FIGURE 5.4B:**
Apple's iPhoto pro-
gram provides the
same functionality
but for Mac users.

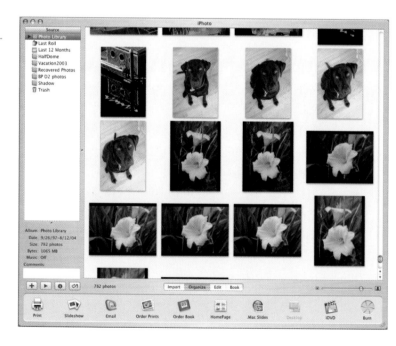

For many photographers, though, this is the best way to work. Using one software tool to import, manage, share, and archive your images makes a lot of sense, and takes all the hassles out of managing your growing photo collection.

For the Organized

If you're a highly organized person, you might want to take a different approach to the process. Many photographers prefer having a greater hand in the organization of their images, so they turn to both software and planning to manage their files.

In this style of image management you'd start off by creating folders with a naming system that makes sense to you. Many people begin by making a folder for each year, and then inside that a folder for each day's pictures. Different operating systems handle filenames differently, so it's a good idea to name folders using only letters, numbers, and just a few standardized symbols.

TIP

Avoid using punctuation in your filenames. Different operating systems assign special meaning to some symbols, so you might run into trouble when sharing photos with someone using a different operating system. The underscore, however, *is* safe to use on just about any operating system, and it is actually sometimes a better choice than a space. People use an under-score between_words_instead_of_spaces to avoid any filename problems on systems that don't handle the space well.

Many cameras, such as those from Nikon and Canon, come with software that will not only copy the images from a media card, but will also rename them at the same time. Some third-party products, such as Camera Bits Photo Mechanic (www.camerabits.com), do this as well. Whatever software tool you use, take advantage of this renaming feature, since it allows you to change that pesky DSC00145.JPG filename into something that makes sense, like 20040101_NewYearsEve145.jpg.

TIP

Some programs have a "Delete pictures on camera after copying" option or something similar. Do not *under any circumstances* click that check box! If something goes wrong in copying the files the first time, you want to have the ability to try again. Check your computer to make sure the files were copied correctly, and then delete them by using your camera's Format option (**Figure 5.5**).

Format

Format memory card?

[CF] 245MB

8KB used

Cancel OK

[MENU] ↰

◀ **FIGURE 5.5:** After you have verified that your photos have downloaded properly, then it's safe to reformat your media card

IPTC, EXIF, and Bears, Oh My!

Hidden inside every digital photograph is a wealth of information about the image, how it was created, and more. In addition to the visual data stored in a file, each camera sticks in some text in a format called *EXIF* (which stands for Exchangeable Image File Format, which is a good thing to know if you're ever on *Jeopardy!*) that records all sorts of vital shooting information, such as camera make and model, shutter speed, f-stop, white balance, and so on. This info can only be added by the camera and is automatically included in each file.

A second bit of information can be added by the photographer in a format called *IPTC* (International Press Telecommunications Council)—information like keywords and captions, copyright data, and all sorts of other bits of useful text that make it easier to find and deal with images (**Figure 5.6**).

◄ **FIGURE 5.6:** You can attach extra information such as copyright and captions to your image, thanks to a format called IPTC.

Programs that rename files while copying them from the media cards often have the ability to add IPTC data to images, which is something you should take advantage of. When looking for photographs with an image browser or cataloging program later on (see "Some Light Filing," below), you could search in the IPTC data or EXIF data to help you find things faster. For example, you could look for all photographs that have your name in the creator field, have the word *vacation* in the title, and were taken using your flash.

Bears really have nothing to do with digital photography. Sorry if that scared you.

Some Light Filing

The all-in-one programs like iPhoto and Photoshop Album allow you to browse your images visually (so they are called *browsers*), and they also allow you to search for keywords that you can assign to them after you import them. Their ability to search through EXIF or IPTC data is a bit limited, however, and this is one of the reasons why some people turn to separate programs to handle the different parts of the workflow.

Cataloging programs usually combine a browser with the ability to perform complex searches on filenames, IPTC data, EXIF information, and more. They can usually create albums of images and enable you to share them with others (see Chapter 7). They use a *database* of information on the files to allow you to quickly perform complex searches.

Some of the more popular cataloging programs are Extensis
Portfolio (www.extensis.com), iView MediaPro (www.iview-
multimedia.com), and Canto Cumulus (www.canto.com). These
programs (and others like them) all look at each photograph
added to them, and pull out information for the database. They
not only look at file information like EXIF and IPTC data, but
they also can use the names of the enclosing folders or even the
files themselves to help create searchable keyword lists. These
applications often keep track of audio and movie files as well, and
they can watch a specific folder, automatically adding any new
files to the database (**Figures 5.7a, 5.7b,** and **5.7c**).

◀ FIGURE 5.7A:
Cataloging pro-
grams such as
Extensis Portfolio
let you create gal-
leries of your
images as well as
perform complex
searches on file-
names.

◄ FIGURE 5.7B: Cataloging programs also let you import images from a folder and can even be set to automatically catalog an image as it is added to that folder.

◄ FIGURE 5.7C: In addition, these programs give you a lot of options for importing images including how large the thumbnails will be and whether you want to rename the files while importing them.

Save Yourself

The final, and possibly most important, thing you'll want to do with your images is back them up. Computers fail, hard drives crash, CDs go bad, and pirate curses can destroy your data. (That last one happens only if you've taken photos of pirate ships or stolen gold from a pirate.)

Without a good plan for backing up your images, you're one power surge from losing all your precious photos. Too many people find this out too late. *There's no such thing as a computer that doesn't crash.*

Professional photographers invest serious time and money into systems that automatically archive their information. When it comes to automated backups, there are a ton of great programs on the market, but the king of data backup is Dantz's Retrospect (www.dantz.com), a program that's powerful enough to safeguard entire companies but easy enough to be used by computer novices (**Figures 5.8a** and **5.8b**). Retrospect has a wizard that walks you through setting up a data-backup routine and can archive information to any sort of backup device available.

Some companies take a more hardware-oriented approach, offering drives that automatically sync when connected or when you push a button. These are great systems, but it's too easy to forget to push that button every day.

▶ **FIGURE 5.8A:** Retrospect packs some powerful data-backup capabilities behind a very friendly interface.

▶ **FIGURE 5.8B:** When backing up your files, Retrospect keeps you updated on the progress of the copy.

The all-in-one programs and cataloging tools usually include a way to burn a CD or DVD of an album of images, which is a great way to create a backup of your most priceless pictures (**Figure 5.9**). Some photographers back up every single shot to optical media like a DVD.

You can create a great backup plan that's much simpler and cheaper without much effort. The most important thing to remember is that once your data is gone, it's gone. Archiving crucial information (not just photos but all your computer data) should be followed as rigorously as brushing and flossing your teeth.

Here are some simple ideas that can help guide you to the per-
fect archiving solution.

- Archives are broken down into online, nearline, and offline.
 Online archiving involves copying files from one hard drive to
 another that's in the same computer or attached to the com-
 puter. Nearline archives are kept nearby but aren't connected
 to the computer except during the copying process and don't
 use the same power supply as the computer (so they're not
 affected by power surges that might affect the main computer).

▼ **FIGURE 5.9:** All-in-one programs such as iPhoto let you burn an album
of images to a CD or DVD.

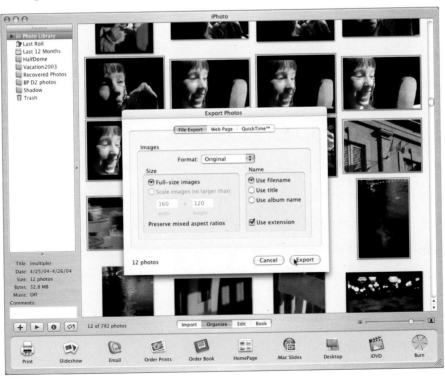

Offline backups are usually created locally and then moved to another location.

- Online archives are the fastest to access but the most prone to getting destroyed in the case of any disaster that affects the main computer. Nearline is less convenient but less prone to theft or power surges. Offline archives won't be affected by anything that hurts the main computer, but it's inconvenient to pull files from them.

- Anything you *really* care about should be backed up and stored in several locations.

- Hard drives can fail or be erased. CDs and DVDs scratch easily. Tape backup systems can snap. Make sure your important files are backed up on several different media types.

- The longer you wait between backups, the more data you have to replace in case of a crash. It's harder to re-create a week's work (and impossible to replace once-in-a-lifetime photos) than it is to archive your data daily.

TIP

Looking for a good place to store an offsite backup? Swap CDs regularly with a good friend or family member and you'll both have an archiving reminder system and a storage location.

A Good Strategy

So if everything can fail or break or get demagnetized, what's a good way to preserve precious photographs?

A good program might look like this:

- Use an external hard drive and a program that automates back-ups to copy your information daily to that drive.

- Create two CD or DVD copies of your important photos. Keep one copy in your home and another copy at a different location.

- When you fill up that external hard drive, move it to another location as an offsite backup, and use another hard drive to protect your files onsite.

- Cataloging software can help you make—and track down— media on backup CDs or drives. If you use cataloging software to create CD or hard drive copies of your pictures, it automatically remembers the locations of those backup files. If you ever need to replace a missing file, it will prompt you to enter the correct CD or DVD or plug in the right drive. Be sure, however, to name each CD, DVD, or hard-drive differently (**Figure 5.10**). And remember, you'll still need to archive the catalog database file along with your other important data.

FIGURE 5.10: It's a good idea to archive all of your images on multiple CDs or DVDs. Just be sure to come up with a naming scheme that makes sense to you.

Photos by the Thousands
Creating a new way to organize your images

How you organize and store your pictures is one of the biggest ways that digital photography differs from shooting film, as Bill Durrence discovered partly through trial and error.

In more than 25 years as a photographer and teacher, including 9 years of teaching in the Nikon School of Photography, Durrence has taken tens of thousands of slides. "My archiving system, such as it was, was organized primarily by subject or location, and I kept the slides themselves in plastic slide sleeves that were filed in hanging folders," he says. So, for example, every slide he'd ever taken of his hometown, Savannah, Georgia, might be filed in a folder labeled "Savannah" regardless of whether it had been taken in 1975 or 1995. "For the most part, I could always find what I wanted with that system," Durrence says.

"The way these CDs were building up, if I was going to find a particular picture, I'd have to put a lot of CDs in the computer and search them visually."

"I started shooting digital about five years ago," he continues, "and, essentially, I duplicated the same organizing system I had." On his computer he would create folders labeled by subject or location and then place pictures in the appropriate folders. Savannah shots went into a computer folder named "Savannah." When he wanted to make backup copies of his pictures or move them off his hard drive, he would burn these folders to CDs. This meant that some Savannah

pictures would be on one CD, and others that he'd taken more recently would end up on a different CD. Says Durrence, "The way these CDs were building up, if I was going to find a particular picture, I'd have to put a lot of CDs in the computer and search them visually."

Durrence could see that his slide-based system was unsuited to digital images and began thinking about alternatives. "I realized I could use the database searching tools [available with digital photography] to find pictures, if I just did the work," he says. What he means by work, Durrence explains, is the process of creating, and then adhering to, a logical system for naming and captioning his digital pictures, and using an image-cataloging program to manage them.

Now Durrence creates folders on his computer that are named by year/month/day/subject (for example, 20040812_savannah). Using an image-browsing program such as Camera Bits Photo Mechanic, he downloads his pictures from their media cards to these folders,

renaming each picture using subject/year/month/day/image number (for example, savannah_20040812_0001). With this naming scheme, his folders automatically sort in chronological order, making it easy to segregate what has already been backed up from what has not.

Durrence also uses the batch captioning features of programs like Photo Mechanic to automatically insert keywords and descriptions into the IPTC fields of each of his images. He tries to discipline himself to do this at the time he downloads the images from camera to computer. The information in the IPTC fields can be searched by his cataloging program, Extensis Portfolio, allowing him to find pictures of particular subjects even though they are now organized by date and only secondarily by subject.

Durrence also disliked the slow speed and clumsiness of CDs. "So I decided to go to external hard drives for backing up," he says. "I worry about power outages, and about me screwing up, so I copy each image to two different hard drives, and I plug each hard drive into separate power supplies." He also periodically burns two sets of DVD copies of the data on the hard drives. One DVD set is kept at his house; the other is kept off-site. In the end, each of his images is stored on two separate hard drives and two sets of DVDs, one of which would escape harm even if a catastrophe struck his house.

—EAMON HICKEY

How to Fix Your Pictures

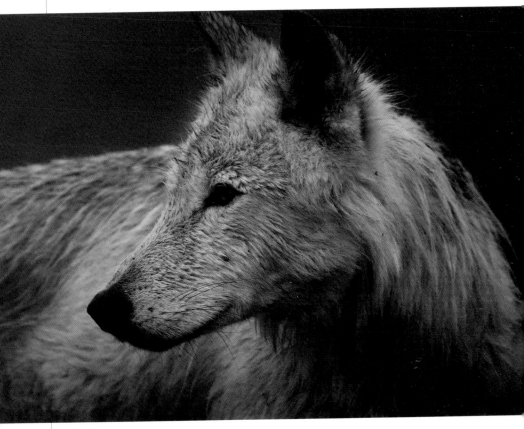

(and Remove Red-Eye,
Zap Blemishes, and Fix Colors)

Even the best of photographers need a little help sometimes. Professionals regularly spend a huge amount of time working to capture the perfect photo, but sometimes even that hard-won photo has flaws. Hey, nobody's perfect—not even the 'Coach.

Occasionally photographs just need a little rescuing—a few little touch-ups to transform them from near disasters to decent images. Even better, sometimes those touch-ups can turn a nearly perfect shot into a masterpiece (**Figures 6.1a** and **6.1b**).

▶ **FIGURE 6.1A:** The composition in this photo of a wolf is stunning, but the muddy color of the image makes the photo fall flat.

▼ **FIGURE 6.1B:** Just a little touch-up work in a software program, however, turns the photo into the masterpiece it was meant to be.

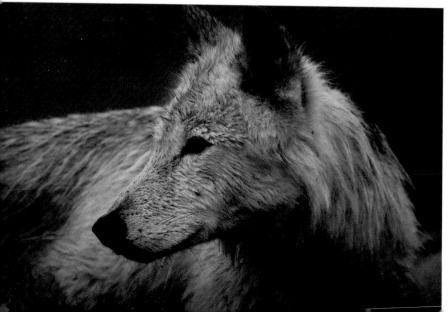

Fortunately, digital photographs are much easier to fix than film photos. They allow anyone with a little time and a bit of software to touch up minor problems like a pro.

TIP

Are you crazy??? Don't even think about modifying an original image! Always, always make sure you keep the original image and work on a copy.

Just make sure that you are working on a copy of your image and not the original. All-in-one programs like Apple's iPhoto and Adobe Photoshop Album automatically save backups of your photos when you make changes, but if you're using a photo-editing program instead, select Save As from the File menu before you get to work. Give your file a new name that will let you know you worked on it, such as david_30th_bday00145retouched.jpg or leslie golf outing 02a.jpg.

Your original image will stay on your hard drive with the original name and will be untouched from this point on. Instead you'll work on the new file with the new name. Make as many changes as you want—you can always open up the original and start again.

Red-Eye Redux

The PhotoCoach has already gone on and on about red-eye (see Chapter 4) and how to reduce the chances of having the subjects in your photographs look like they are demons. Camera techniques for reducing red-eye aren't foolproof, though, and sometimes people will still end up with Glowing Eye Syndrome.

When you're stuck with a photograph that has some hellacious red-eye, it's time to unleash the power of software to help you out (**Figure 6.2**). There are dozens and dozens of photo-editing programs on the market that have red-eye reduction tools, and many of the all-in-one photo album programs include the tools as well. You can choose any of these programs to fix the glowing red eyeballs created by your camera.

The process couldn't be simpler once you've found the red-eye reduction tool included in your software program. In most programs you use the selection tool to first draw a box around the offending eyeballs. Then you click the red-eye button or select the red-eye removal choice from one of your program's menus, and voilà! No more monster photos (**Figures 6.3a, 6.3b,** and **6.3c**).

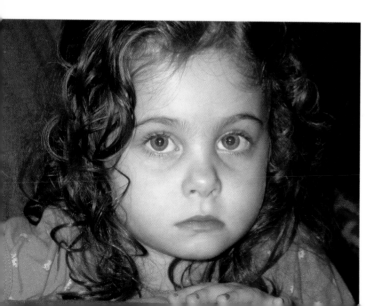

◀ FIGURE 6.2: Fear not! You can easily fix the demonic look in this girl's eyes.

◀ **FIGURE 6.3A:**
To get rid of that red-eyed glint, first choose the photo you want to fix.

◀ **FIGURE 6.3B:**
Click the Redeye Auto Fix button (or its equivalent in your software program) to target the red spots.

◀ **FIGURE 6.3C:**
As if by magic, the red eyes become normal eyes.

Oh, Crop!

Zapping red-eye might be the most obvious fix you can do to improve your photographs—and it's certainly something that can save an otherwise ruined shot—but many other post-photographic touch-ups are more subtle and just as important.

A great place to start looking to touch up your photograph is by refining the focus of a shot. I talked before about doing your cropping work in the camera (see Chapter 2), but sometimes that's just not possible, or you might later notice a way to improve your photograph simply by trimming it down a bit.

▼ **FIGURE 6.4A:** This is a pretty good photo to start with, but it can be improved by cropping.

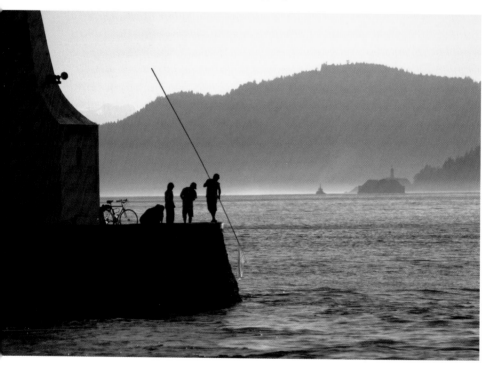

The cropping tool is an important weapon in the arsenal against bad photographs. This mighty little tool is your key to perfecting an image through the art of selective removal (**Figures 6.4a** and **6.4b**). Some programs put the cropping tool in a floating palette, while others leave it in a toolbar or in a section grouped with other photo-editing tools. No matter where it's kept, the cropping tool always does one thing: It removes part of your photograph.

▼ FIGURE 6.4B: When uninteresting details such as the dark structure on the left and extra sky and water are removed the image becomes much more interesting as your attention is directed to the important elements.

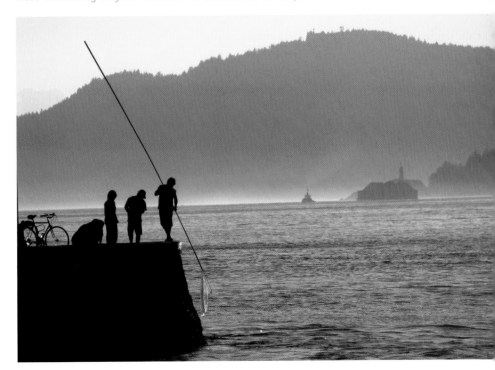

TIP

You did remember to save a copy of your original image, didn't you? NO? OK, pay attention. This is important. Always, always perform a save as to maintain your original image before doing a destructive edit such as cropping.

Remember that when you crop, you are effectively *throwing away* part of your data. If you've got a 5 megapixel camera and you crop out half of the frame for a closeup, you might end up with no more data than if you took a close-up shot using a 2 megapixel camera. You won't be able to print the cropped picture as large as the original or resize it without making it blurry. That's why it's better to crop in your camera by getting the composition right in the first place.

Simple Cropping Steps

Here's how to crop an image:

• Move the cropping tool to one corner of your photograph, and place it on the innermost part of the section of the image you'd like to keep. Don't worry if you're not precise—you can move it around later.

• Click and hold the mouse button, and drag the cursor to the opposite diagonal corner.

• Let go of the cursor, and notice that part of your photograph is now light, and some is dark. The lighter area is the portion that will remain after the crop; the darker area will be removed.

- If you don't like the way the light area looks, move your cursor to one of the little circles in the corners to resize the cropped area. *Some programs don't let you resize the area. With these you have to reselect your crop region with the tool again.*

- Press Enter or Return to accept the change.

You can use the crop tool to remove regions of the image that are distracting, or use it to turn a wide-angle photograph into a close-up shot. Whatever reason you use the cropping tool, try to be careful in your selection. It's easier to crop more of the photograph later on than to try to recover from an overzealous trimming.

Color (Correct) My World

Another handy thing about digital photography is that it's so darned easy to fix lousy colors. Digital cameras do a great job of capturing color these days, but really there's no way to make sure that every photo comes out perfect every time. Plus some photos just look better when you adjust their color. Making them black and white or sepia or just adjusting the color balance can help create an artistic photograph without much effort.

Start off once again by making a copy of your original image and then look for your program's color-balance tools. In all-in-one programs, these are usually found in the Edit section of the program. Clicking these buttons usually brings up a range of tools, including sliders and buttons for color changes.

Photo-editing programs such as Adobe Photoshop Elements or Jasc Paint Shop Pro have their color-changing tools in the menus, allowing you to choose from a range of options to modify your colors.

Adjusting Color in Two Different Ways

Adjusting your colors is a snap, and it's easy to do no matter what kind of software program you're using. I'll show you how to do this in iPhoto and in Photoshop Elements. If you have a Macintosh, iPhoto comes free with your machine; Photoshop Elements is bundled with many digital cameras. If you don't have these programs, don't worry—all the leading programs do the same thing; you just might have to look for the color-adjustment choices in the menu.

ADJUSTING COLOR USING APPLE'S IPHOTO

1. Click the photo you'd like to edit.
2. Click the Edit button in the toolbar below the photograph.
3. If you'd like to change the color balance manually, adjust the Brightness or Contrast sliders (see "None Too Bright," below, for more information).
4. To instantly convert the photos instead to black and white or sepia (which is a brown color reminiscent of that found in old photographs), simply click the B&W or Sepia button.

ADJUSTING COLOR USING ADOBE PHOTOSHOP ELEMENTS

1. Open the photograph you'd like to edit.
2. Choose Save As from the File menu and save the photo with a new name.
3. From the Enhance menu you can choose Auto Color Correction to allow Photoshop Elements to automatically try to fix the color based on expert settings.
4. To convert the photograph to black and white, choose Remove Color from the Adjust Color choice in the Enhance menu.

▲ **FIGURE 6.5:** The Enhance menu in Photoshop Elements provides numerous options for making your photo better.

5. If you'd like to change the color manually, choose Color Variations from the Adjust Color choice in the Enhance menu (**Figure 6.5**).

6. To adjust the brightness and contrast (see "None Too Bright," below, for more information) select Brightness/Contrast from the Adjust Brightness/Contrast choice in the Enhance menu.

None Too Bright

In "Adjusting Color in Two Different Ways," above, I talk about the steps needed to adjust a photo's brightness or contrast. The idea behind brightness and contrast is pretty simple, and often a little tweak of the settings can turn a dull photograph into a lively one (**Figures 6.6a** and **6.6b**). Still, the difference is a subtle one, so let's look at it a bit more closely.

Brightness. The brightness of a color has to do with how much black it has in it. Think of taking a cup full of red paint and then adding a drop of black to it. The red gets darker but continues to be red. Drop in another blob of black paint and it gets darker still. In a photograph, the brightness slider controls how much black is in the overall colors.

▲ FIGURE 6.6A: The original image is just too dark.

▲ FIGURE 6.6B: Using iPhoto for a few gentle tweaks to brightness and contrast, however, brings this colorful photo to life.

The farther you go toward bright, the closer to white each color becomes, and the farther you slide the controller to the dark side, the more black is in each color. Slide too far to white and everything gets so light it's hard to tell the colors apart. Slide too far toward black and you can't see a thing.

Gently adjusting these sliders can help reveal hidden details in an image and can possibly save a photograph that suffered from a bit of over- or underexposure.

Contrast. This refers to the difference between the lightest and darkest parts of an image. Let's say that in a normal picture white has a value of zero on a scale of 0 to 100 and black has a value of 100.

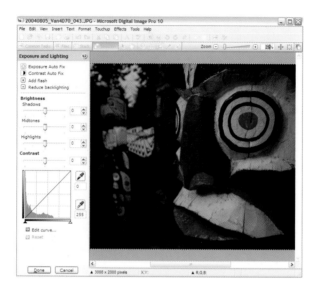

▲ **FIGURE 6.7A:** Again, the original image is just too dark.

▼ **FIGURE 6.7B:** Using the sliders in Microsoft Digital Image Pro, the brightness has been adjusted. A slight change in contrast also helps pump up this photo.

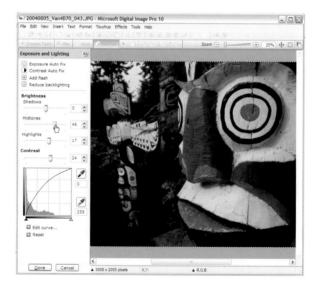

Each picture has a balance of how close the lightest color value is to the darkest color value on the scale.

When you adjust the contrast slider, you change the relationship of those colors. Slide left and that range is compressed, resulting in colors with fewer differences between them. Slide right and the differences in colors become more extreme. Contrast adjustments need to be performed carefully. Just a little movement of a slider makes a huge difference (**Figures 6.7a** and **6.7b**).

Caught You Off Balance

Because cameras see colors differently than our eyes do, digital photographs frequently need a little color tweaking. The same color-balancing act is needed for film cameras too. When you bring your film to a photo lab, the machines that turn your negatives into prints perform automatic color correction. Fortunately, with digital photos it's not hard to get the color on your screen or printer to match the colors you saw when you took the picture, and it can really help make a picture look more lifelike.

Often a picture will end up being a bit too red or green or blue—it's said to have a *color cast*. There's nothing wrong with a color cast, mind you, but it's easy to pick out a photograph that doesn't look exactly right.

There are three different ways to correct color-balance problems with software, and most programs offer one or more of these methods. Here are your choices:

• **Automatic correction tools.** Available either through a button or a menu item, these tools provide all-or-nothing correction, meaning that the program analyzes your photograph, decides what sort of changes are needed, and then does them.

- **Variation-based tools.** These color-correction tools provide an easy *pick-and-choose* selection system for fixing color. The original image is displayed as a thumbnail. Sample boxes sit alongside or underneath the original image, displaying the various color-correction options from which you can choose.

- **Slider-based tools.** As with brightness and contrast, these tools let you change the colors in an image by adjusting the *hue* (what color things are), *saturation* (how much of the color is present in the image), and *brightness* (this is the same brightness as described above, and it controls how vibrant the color seems). This type of correction tool is the most difficult to master (though it can create some really fascinating results) so we'll focus on the other two in the next section.

You're So Picky

Image color correction is a snap with all-in-one programs and photo-editing programs. Here we'll use iPhoto and Photoshop Elements to illustrate the two easiest color-repair techniques.

FIXING COLOR IN IPHOTO

1. Select the photograph you'd like to adjust.
2. Click the Edit button on the toolbar underneath the photograph.
3. Click the Enhance button to let iPhoto automatically correct your photograph.

FIXING COLOR IN PHOTOSHOP ELEMENTS

1. Open the photograph you'd like to edit.
2. Choose Save As from the File menu and save the photo with a new name.

3. From the Enhance menu you can choose Quick Fix to let Photoshop Elements automatically fix your photograph.

4. If you'd like to fix it using Variations, select Color Variations from the Adjust Color selection in the Enhance menu.

5. A dialog will appear with your photograph shown before and after any changes. Below your photo are a series of thumbnails displaying the various color correction options. Simply click any of the boxes to experiment with the change.

6. When you like your photo, click the OK button.

Sharp as a Tack

An unsteady hand or a vibration can cause a photograph to be a little less than sharp. (The PhotoCoach has some family members that are not too sharp, either, but that's a different story.) While it's not possible to rescue a totally out-of-focus photograph, it's easy to add a little sharpness to it.

Most of the time, though, you'll sharpen your photograph before printing it out or saving it to the Web, as both of those processes can dull the edges of an image. If you'd like to find out more about sharpening your images, turn to Chapter 8.

Remove the Blemishes

As someone who is always getting food on his shirt, I can tell you that there's nothing worse than a photograph with an unsightly blemish, stain, or (gasp!) pimple. Luckily, there's nothing easier to fix, and with a few clicks o' the mouse you'll have a picture that's as spot free as glass out of the dishwasher.

There are two tools that are used to remove unwanted little elements from a photograph. The retouching tool found in many programs couldn't be simpler to use (**Figure 6.8**). Click and hold the mouse button as you run the tool over the area with the unsightly and offending blemish, when you release the button, the mark will be gone.

Many more programs use a clone tool, which enables you to remove an area by replacing it with another bit of your photograph (**Figure 6.9a**). With the clone tool selected, place the cursor over a source area that you'd like to use as a replacement for the area with the blemish (**Figure 6.9b**). Alt-click (PC) or Option-click (Macintosh) to select the area. Next, click and hold on the area you'd like to replace, and use the clone tool to "paint" away the troublesome spot (**Figure 6.9c**).

▲ **FIGURE 6.8:** The retouching tool in most programs is represented by an icon that looks like a small paintbrush.

▲ **FIGURE 6.9A:** A clone tool is usually represented by an icon that looks like a rubber stamp.

▶ **FIGURE 6.9B:** Use the clone tool to select an area of your photograph that you want to use to replace the blemished spot.

▼ **FIGURE 6.9C:** Now simply use the clone tool to paint away the blemish.

SAVING THE WEDDING DAY
Turning a too-dark image into a work of art

For a recent wedding client, Michael Schwarz used his image-editing skills to save a great picture that was nearly ruined by a mishap known (at least to him) as Schwarz's Law.

Schwarz was shooting the newlyweds during their first dance. He was using a powerful external flash attached to his camera, and as the couple danced, he was firing a rapid sequence of pictures. "There were 5 or 6 seconds where she was spinning and laughing, and it was just a beautiful series," Schwarz says. "The light was perfect. The moment was perfect."

When you are shooting a rapid sequence with flash, however, the flash sometimes cannot recharge fast enough to keep up. Professional cameras, unlike most amateur cameras, will go ahead and shoot regardless, so you can end up with a sequence of, say, eight shots in which the flash did not fire on the fifth frame. That frame will be

very dark, but it might be a great composition, or hold the peak of the action, or capture a great expression on the subject's face.

That, Schwarz says, brings us to his maxim: "Schwarz's Law states that in any rapid sequence of shots with flash, the best shot will always be the one where the flash didn't go off." And so it was in this case.

"I looked at this image," says Schwarz, "and it's about four stops underexposed. I figured it was not going to be usable, but I liked it so much, I decided to play with it." He brightened it up in Adobe Photoshop and liked what he saw, except that the picture had terrible electronic noise, which looks like multicolored grain. To combat that, Schwarz worked on the image using PictureCode's Noise Ninja program, which minimized the appearance of noise. Then he converted the picture to black and white, which further reduced the visual effect of noise.

"It ended up looking gorgeous," he says. "It went from being unusable to being a beautiful image, and they loved it."

—EAMON HICKEY

ARTIC LIGHT
Using filters to fix a pretty, but problematic image

In June 2004 Reed Hoffmann was teaching a photo workshop called "Arctic Exposure" on a cruise ship bound for Alaska—nice work if you can get it!—when he shot a picture that had potential but needed some doctoring.

He was standing on the ship's stern one night at sunset, "and there's this beautiful scene of the wake trailing behind us in the fading light," Hoffmann remembers. "It was lovely."

Because of the low light he had to use a long shutter speed, which is likely to cause motion blur if you're shooting on a moving ship. Plus, his camera muffed the white balance. "I made a really pretty picture," he says, "but it was too blue and not perfectly sharp." Still, Hoffmann liked the scene and decided to use his image-editing

program, Photoshop, to turn the photo's problems into virtues. "I felt it might look better as something reminiscent of the 1920s or '30s, rather than something from a modern luxury cruise ship.

"So I took the picture and made it black and white. That got rid of the color problem." Next, he used an add-on filter called Old Photo: Black and White, from the nik Color Efex Pro 2.0 suite of Photoshop enhancements. In Photoshop-speak, software special effects are called *filters*.

Using the Old Photo filter, Hoffman says, "I added grain to the picture because I wanted to mask the fact that it wasn't really sharp. And I knocked the contrast down a bit.

"I like the picture a lot that way. I use it when I'm teaching work-shops because it points out that the image in your camera might not match the image you were hoping to get, but there are tools that will let you get closer." —EAMON HICKEY

How to Share
Your Photos

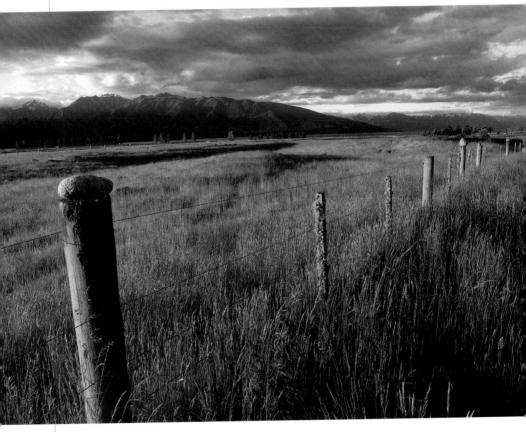

Everything You Need to Know About

Showing Off Your Photos

WHY DO WE TAKE PICTURES IN THE FIRST PLACE? Sure, photography is fun, but when it comes right down to it, most of us are taking pictures to share them with someone else. Film photos are easy enough to show off to folks you come in contact with, but they are very difficult to share with far-off friends or with a group of people who want a copy. Sharing film photos inevitably means taking a trip to the 1-hour photo lab to get somewhat expensive duplicates.

Digital photography is all about sharing. Everything about the very nature of digital makes it as easy to show your pictures to someone sitting next to you as it is to show them to friends on the other side of the world.

The most popular ways to share your photos are by printing them, sending them via email, creating online slide shows, and posting them on the Web. You're just a few mouse clicks from sending pictures to your friends, and from creating galleries of your images.

Send Them a Picture

One of the most rewarding things about digital photography is that mere moments after an image is captured, it can be sent to anyone, anywhere. For this reason newspaper and wire service photographers were among the very first to embrace digital cameras, using them to turn in photos even while news was breaking. The successes of these intrepid pioneers helped bring the technology to photographers everywhere.

The most reliable way to send a photograph to someone is via email, and the simplest way to send it is as an attachment. Simply open your email program, click the attachment button, and navigate to your file. Put in the address of your lucky recipient and click the Send button.

All-in-one programs such as Adobe Photoshop Album and Apple's iPhoto have a Share or Organize tab that has a button for sending a photo (or group of photos) as an email attachment. Select one or more photographs and click the Email button or select the Email menu item in the Share or Organize pane, and the program will automatically launch your email program and create a new email ready to address (**Figures 7.1a** and **7.1b**).

▲ **FIGURE 7.1A:** To email a favorite photograph to a friend from an all-in-one program such as Photoshop Album, simply select the email menu option.

▲ **FIGURE 7.1B:** Photoshop Album will then create a new email ready for you to address and send.

Size Matters

Depending on the camera you're using and the settings you've chosen, however, the photograph that you want to attach might be way too big to be easily sent to someone else or uploaded to a Web site. The first consumer digital cameras on the market had imaging sensors that contained only 1 or 2 megapixels. The small sensor size of the cameras resulted in small files. Today's digital cameras, however, contain much larger sensors—typically 3 to 5 megapixels—and the resulting image sizes are much larger.

What do we mean by all this? It's very simple. A digital camera's sensor is made up of a series of teeny dots called *pixels*. (Pixel is a computer geek's abbreviation for *pixel elements*.) These pixels are arranged side by side in rows stacked on top of one another. The number of pixels determines the device's *resolution*, a term that simply means *how detailed is your image* (**Figures 7.2a** and **7.2b**). The more pixels available to capture an image, the more information the camera can record. Resolution is just another way of talking about how many pixels are used to make up an image. A digital camera might be called a 5 megapixel camera because its sensor has 2500 pixels across and 2000 pixels down (2500 by 2000 equals 5 million pixels, or 5 *mega*pixels).

But each new wave of cameras comes with advances in sensor sizes, and those cameras can create bigger files than their digital photographic ancestors. The increase in file size is great news for digital photographers—larger files give you the ability to create bigger and better prints, and also let you maintain maximum detail if you need to crop a photograph. (When you crop a photograph, you use a computer program to slice away excess imagery from a photo.)

◀ ▼ **FIGURES 7.2A** and **7.2B:** You can clearly see the pixels that make up this photo in the enlargement.

Digital cameras also typically save their images in a format called *JPEG* (pronounced "jay-peg"), which is a method of compressing the information recorded by the sensor into a smaller file. To create a JPEG, the camera analyzes the image and removes some detail using tricks to keep the picture looking good. Most cameras have a JPEG compression selection, which allows you to squeeze more photographs onto a digital media card by using a higher level of JPEG compression. The more you compress the image, the worse it looks, especially when printed, so it's usually a better idea to purchase a higher capacity memory card than to use the lower compression settings.

Since newer cameras allow photographers to take pictures with greater detail, some cameras (usually the ones aimed at more advanced amateurs) allow photographers interested in ultimate picture quality to save in a format such as TIFF or RAW. Neither format is compressed, so no picture information is lost, but the resulting file is much larger than a JPEG one.

Fortunately, media cards used by digital cameras (as well as the computers used to share photos) have kept pace with these technological changes and can easily handle the larger file sizes. The first media cards for digital cameras were typically no more than 16 MB in size, and 1 megapixel and 2 megapixel cameras created files that only took up a fraction of the card's capacity. These days, media cards top out around 4 GB, while an average-size card weighs in at around 256 MB. The current crop of advanced-amateur cameras can create files that are as big as 20 MB in an uncompressed format like TIFF.

Avoid the Preset Sending Limits

These larger file sizes are a boon for the creative photographer—there's so much more you can do with a large high-quality file than with a smaller file where the image is saved in a very compressed format. But what happens when you try to email someone an uncompressed TIFF file from an 8 megapixel camera? The worst-case scenario is that your photograph won't ever make it off of your computer. Many Internet service providers (ISPs) set file-size limits for outgoing email in order to prevent people from trading things like music or swapping illegal copies of programs. Even with a high-speed Internet connection like DSL or cable modem, if you attach a file that exceeds your ISP's limit, it will get stuck in your mail program's out-box as it tries to send the file over and over again, failing each time.

Sometimes a large photographic attachment will end up causing problems for the recipient instead. Even if you've got a broadband connection at your house, there's no guarantee that the recipients will or that they'll check their mail from a high-speed connection. With so many email-enabled devices (like cell phones and PDAs), many people view their mail on really slow connections. Big files are hard to view on the road.

In addition, the person you are sending the file to may not even need a high-resolution version. For example, if all he wants to do is simply view the image and then delete it or use it as a desktop background, then a small file size (and, thus, lower resolution) is just fine. If he wants to print it for framing or another project, then it's best to send the highest-quality image you can.

The solution? Check with the people you're sending a file to, and find out what sort of connection they have and what they

plan to do with the file. If they've got a high-speed connection and want to print the photograph, sending them the original image is no problem. But if they've got a dial-up account or just want to use the picture as a background on their desktop or for some other low-resolution use, it's best to resize the photograph to make the file size smaller.

Resizing is simply the act of taking the large original file and making another version of it small enough to attach to an email without clogging anyone's in-box. Since you don't want to over-whelm the person receiving your pictures (nothing says *ignore this email* like an unexpectedly huge attachment), it's a good idea to let your all-in-one program or your photo-editing program do the resizing work.

TIP

I can't tell you how many times I've heard the story about the person who gets a new high-megapixel digital camera and begins emailing dozens of huge photographs to every family member, clogging their email programs for hours. That's why it's always best to see what sort of file your recipient wants each time you send photos.

Keep the final use of the picture in mind when resizing it. If Grandma just wants to see a picture of the new baby, don't send her the full-size image. If she'd like to print it out, don't send her a resized photo.





Visit Your Shrink

Some photo-editing programs, such as Adobe Photoshop Elements, have an Attach as Email or similar selection in the File menu that will resize your photograph correctly and automatically create a new email for you with the file attached.

For those photo-editing programs without a handy button or menu item for automatically attaching a file to an email, you'll have to change the file size yourself. Here's how to do it, using Photoshop Elements, for example.

1. Open the photograph you'd like to edit.

2. Chose Save As from the File menu and save the photo with a new name. (If your photo isn't saved in the JPEG format, do so now by choosing JPEG from the Format pull-down menu.)

▼ **FIGURE 7.3:** Photoshop Elements' Image Size dialog shows you the image's resolution in pixels at the top and the image's size at that resolution at the bottom.

3. Choose Image Size from the Resize choice in the Image menu. The Image Size dialog will appear with the image's resolution in pixels provided in the top box, and its size in inches (at the selected resolution) listed on the bottom (**Figure 7.3**).

4. You can either change the pixel information in the top section to match what you need, or change the height, width, and resolution in the bottom section. To use the top section you'll need to do all kinds of math, so it's easier to just plug in numbers in the bottom section (**Figure 7.4**).

5. Enter the size you'd like the email-attached photo's width to end up (in inches) in the width box. Notice that the height field automatically changes to the correct value.

▼ FIGURE 7.4: It's easiest to change an image's size using the width and height dimensions in the bottom segment.

6. Next, change the resolution. If the image is only going to be viewed onscreen, change the resolution to 72 ppi. For an image that is going to be printed, check your printer's manual to determine the number to put in this box. A safe bet is to select 300, but some great inkjet printers operate well at a lower number (**Figure 7.5**).

7. Click OK.

8. Save your photo.

9. Open up your email program, click the attachment button, and select your new photograph.

▼ FIGURE 7.5: If you want to print your image rather than just view it onscreen, change the resolution to 300 pixels/inch.

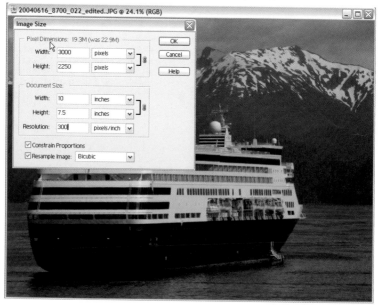

The Shooting Gallery

Creating a Web gallery is another popular way to show off your photographs, and it takes just a few minutes to create one. You'll need an account with a Web hosting service or with an online photo-sharing community to be able to share your pictures with the world, however.

TIP

If you want a really great way to play with your photos, check out the online photo communities, such as Ofoto.com (www.ofoto.com) and Shutterfly.com (www.shutterfly.com). These communities let you store your photographs online and allow you to order prints and albums directly from the site. What's better is that they are one-stop storefronts for your friends and family, allowing them to order copies of your photographs without your having to lift a finger.

There are three main ways to get your pictures from your computer to someplace where other people can view them: putting them on an online photo community via an all-in-one program, manually transferring them to an online photo community, and transferring them to a Web server.

The all-in-one programs are typically linked with an online photo-sharing community, making it a snap to transfer your gallery of images directly from your computer to them. Apple's iPhoto connects right to the company's .Mac account, while Adobe Photoshop Album works with Shutterfly, for example. Simply look for your program's Sharing section, and follow the directions to order prints or albums.

Online photo communities, by comparison, provide Web-based tools that enable you to upload a chosen group of photographs directly to your account. Typically the online tools let you create galleries simply and easily. As an added bonus, if you upload high-resolution photographs to these services, other people can purchase prints of the pictures they like directly from the Web.

The least automated way to share your photographs online is by placing them on a Web server, which is a computer connected to the Internet that shares Web pages available to people surfing the Web. You'll need to manually create a gallery (see "Taking Advantage of Your Hosts," below) using either a photo-editing or Web design program and then transfer those images to the Web server using a tool provide by the hosting company.

In any case, sharing your photographs online requires you to create an account on the community you choose in order to use its Web site. The all-in-one programs allow you to set up your account directly from within the program, saving a step. (To post pictures to a Web hosting company you'll need to contact it directly about setting up your account. This is not for the faint of heart, so it might be best to stick with the all-in-one programs or an online photo community.)

TIP

There's no *best* way to share your photographs online. Even professional photographers and Web designers who are comfortable with using Web servers and have their own Web sites frequently use all-in-one programs or photo communities. They provide a quick and easy way to distribute photographs, and they get rid of the headache of having to print out lots of copies of photos for people.

Sharing with the Community

Sharing photos with an online community is a simple task with an all-in-one program such as Photoshop Album (**Figures 7.6a, 7.6b,** and **7.6c**). Here are the basic steps:

1. Create an album in your software program that contains the pictures you'd like to upload.

2. From the Share or Organize pane or menu, choose the option that says Home Page or Web Gallery or something similar.

3. If you've already set up your account, your images will be automatically transferred to the community's Web site. The program will let you know when the transfer is complete and show you the Web address needed to find the pictures.

▲ **FIGURE 7.6A:** To start sharing your photos with an online community, first create a gallery of photos.

▶ **FIGURE 7.6B:** Pick the people you'd like to notify about your gallery, The program will create an email so that you can write a custom note to your friends and family.

▶ **FIGURE 7.6C:** The program will upload your photos for you. Now your friends and family can log on to the Web and view your photos, order prints, or watch a slide show of your images.

The Direct Route

The online photo-sharing communities work hard to make the process of creating an image gallery as painless as possible. (And that's why I'm so darned fond of them.) Each of the major communities has a different system for transferring your images to it, but they are all pretty simple. Generally speaking, they either require you to download a piece of software that allows you to designate which files should be uploaded and that helps you configure the look of your gallery, or they allow you to use your Web browser to transfer images to their servers.

Any way you slice it, these sites are a great way to share your pictures, and if you work with the same company that is integrated into your all-in-one program or photo-editing software, you can choose to upload to your account either through the program or through the Web interface.

TIP

Being able to access your online photo-sharing community in different ways is extremely helpful if you go on a trip without your computer. Simply track down a computer with a connection to the Internet and upload a few shots to show people in the office exactly how lucky you are.

Taking Advantage of Your Hosts

Creating a Web photo gallery for use with a hosting service is a bit more complicated, but not so much that you'll need a computer science degree to get it done (**Figures 7.7a, 7.7b** and **7.7c**). Basically these are the steps:

1. Create the gallery (see next page).

▶ **FIGURE 7.7A:** To create your own Web gallery, you'll first need to choose your images and export them in HTML. Your program will then display a dialog where you enter information such as the title of your Web page and how many thumbnails you want displayed.

▲ **FIGURE 7.7B:** The program then creates a gallery based on your specifications.

◀ **FIGURE 7.7C:** Viewers can opt to look at any of the images in a larger size to home in on details.

2. Create a folder on the server to hold the images.

3. Upload the images and the Web pages created by the photo-editing program to the server.

The process of performing steps 2 and 3 varies depending on your hosting company, and you should follow its instructions to avoid causing any problems with your Web pages.

Creating the gallery, however, is a simple activity, and the photo-editing programs make it easy to create an attractive Web page with your images displayed professionally. In a nutshell, here are the steps:

1. Move a copy of all the images you'd like to share to the same folder.

2. Use your program's Web-gallery-creation tool to make a gallery. In Photoshop Elements, this is the Create Web Photo Gallery choice from the File menu.

3. The program will launch a wizard to configure the creation of your gallery. You'll need to choose a style for your gallery, specify the source folder (your folder containing the copy) and the destination folder (create another folder to hold the finished gallery files), and give the program information to display on the pages.

The end result will be a folder full of Web pages and subfolders (that contain the gallery images, resized to display well on the Web). Some photo-editing programs also allow you to directly upload images to the online photo communities, without having to upload a gallery. Check your program's manual to see if there's a one-step method for gallery creation with one of the big photo communities.

Slide Shows in the Modern Age

Someday people are going to wonder where the term *slide show* comes from, as the use of film fades into memory. In order to give photographers a familiar metaphor for creating a computer-based display of chosen photographs, software designers chose to call the new tools by the old name.

Modern slide shows are so much more powerful than the carousel-based displays of days gone by. These days you can create slide shows that play music while your photographs are displayed. Slide shows can even include annotation and special effects and can be saved to CD or DVD or even emailed so that other people can view your shows as well. And you don't need to hang a blanket from the wall for everyone to see them.

Countless programs exist for creating slide shows. Both Photoshop Album and iPhoto can create custom shows directly from your albums, and they can link the shows to music from your hard drive's library of MP3s or other audio files.

TIP

If you create a slide show in a format like Apple's QuickTime or Macromedia Flash (two popular formats for creating movies and animations on the Internet), you can upload it to a Web hosting company just as you might with a Web page. Then anyone can check out your slide show just by visiting your Web site.

If software that came with your computer or the programs that came with your camera don't suit your needs, look in your local computer store for some great slide show creation packages. You can also check out computer magazines and Web sites for reviews on the latest programs.

'Tis the Season to Share Photos (Fa-La-La-La-La)

One of the most impressive features of the online communities is that they allow you to create all sorts of fun photo cards and gifts. After uploading your photographs to the community, it's a snap to create a postcard, holiday card, picture book, wall calendar, or, heck, even a photographically enhanced coffee mug or T-shirt with just a few simple mouse clicks.

Once a photograph is uploaded, the sites provide simple Web-based step-by-step tools for easily ordering any number of interesting photographic items. Send a grandparent a tote bag with your child's photograph, or order a framed photo of yourself to be delivered to your girlfriend in time for Valentine's Day. (That might not actually be the most romantic thing to do, but you get the idea.) Popular photographic items include hardbound photo books, spiral-bound flip books, customized note cards, T-shirts, calendars, giant poster prints, and more.

The sites will even (in most cases) mail your gifts directly to the recipients and will go so far as to create custom cards that they'll deliver directly to everyone on your holiday list. In an effort to stay competitive, they add new items frequently, giving you more opportunities to surprise someone you know.

For the do-it-yourselfer, many of the all-in-one programs and some photo-editing applications provide direct printing of greeting cards, thanks to built-in templates. These allow you to select the design of cards, add a custom greeting on the inside, and then print the cards directly from your inkjet. There are shareware programs that are made simply to create custom cards, and the software that comes with many cameras also includes such tools.

Around the Globe

It's easy to send photos to the other side
of the world

The magical transportability of digital photos is fun for the pros
too, but for them it's also a business necessity. It helped Blue Pixel
keep nervous clients calm when the group was shooting Eco-
Challenge Fiji in 2002.

One of Blue Pixel's tasks was to shoot promotional and publicity
photos for some of the TV networks that would broadcast the race,
including cable's USA Network. "The USA Network was nervous," says
Kevin Gilbert, "and I totally understand that. They had a bunch of
photographers running around the jungles of Fiji, and they wanted to
know what they were getting."

So Blue Pixel set up a private Web site where its photographers
could post pictures such as the one at left every day of the roughly
two-week event. Their average daily take—all the photos they cap-
tured in a given day—was 2000 images. Each day, Blue Pixel's Jeff
Lawrence edited these down to a handful of the best and uploaded
them to the Web site using a portable satellite phone.

Art directors at USA Network in New York who would be using the
photos in press kits, on billboards, and in other media could log on
to the Web site and see exactly what Blue Pixel was producing in Fiji.
"We'd get back these emails from them giving us good, constructive
feedback," Gilbert says. "We were connected. They knew they
wouldn't have to go back and reshoot anything. They were getting
just what they wanted, and if they weren't, they told us so. We used
every ounce of technology we could get our hands on to reduce
everyone's stress level."

The pros don't always use satellite phones from places like Fiji, of course. They can be regular old proud parents too, and sometimes the most meaningful pictures they take aren't for publication at all.

One day in 1998 Nick Didlick decided to shoot some pictures of the soccer team that his ten-year-old daughter, Kelsey, played on. "They were just girls' soccer pictures, my daughter and her teammates, nothing special," he says. "But I took 14 of the pictures and put them together in a little gallery and uploaded the gallery to my Web site. I gave the URL of the Web site to my daughter, and she thought it was pretty cool, so she emailed it to some of her teammates." One of those teammates was a girl named Allison, and Allison's mother saw the Web gallery and decided to email the URL to the girl's grand-parents in South Africa.

It turns out that Allison's grandparents had not seen her since she was an infant. "They had just gotten access to the Internet," Didlick continues, "and they get this email, and they click on the link, and up opens this picture of their ten-year-old granddaughter, who they haven't seen in nine years. They'd never seen her grown up. And it brought tears to their eyes.

"I had my email contact link at the bottom of the Web page, and they clicked on that and sent me a great email thanking me for putting up that little gallery and saying how much it meant to them. So that was really cool."

—EAMON HICKEY

How to Make a Great Print

(and What
the Heck Is
a Megapixel
Anyhow?)

HARDLY A DAY GOES BY that the PhotoCoach doesn't wake up and thank his lucky stars that he doesn't have to spend time in the darkroom anymore, thanks to digital photography.

For those of you who are too young to remember, film processing and printmaking used to take place in a room devoid of anything but a dim red light. You were surrounded by toxic chemicals and piles of wasted paper known as *test strips*. Many a great weekend was ruined with trips to the darkroom.

These days any digital photographer has the power to be the master of his or her own images—from pressing the shutter release to printing the image yourself, there's nothing you can't do.

Watching a high-quality image coming out of an affordable inkjet printer is an amazing thing—the process is so simple compared with slaving over a sink of chemicals in a darkroom that it can make anyone's head hurt to think about the old days (**Figures 8.1** and **8.2**). To get a great print, though, you need to understand a bit about what's going on inside your hardware. You don't need to understand enough to become a certified geek, but you do need to know enough to understand what buttons to press, and when.

Let's start our exploration of digital printing by talking a bit about how a camera works, and take it from there.

◀ **FIGURE 8.1:** Epson has long made top-quality, affordable inkjet printers, such as the Epson Stylus Photo 2200, shown here.

▼ **FIGURE 8.2:** Imagine being able to print stunning photos like this with just a click of the mouse!

It's All at the Push of a Button

Inside your digital camera is a little strip of light-sensitive material, and it's this strip that is the heart of digital photography. This strip is actually a silicon chip that's called either a *CCD* or a *CMOS* sensor, depending on how it's built. In several places in this book I've referred to this chip as a *digital imaging sensor* (to avoid having to explain this more than once), but people often just call it a CCD for short.

On the face of the sensor is a grid of dots laid out in straight rows, with one row stacked on top of another row. These dots are called *pixels* (short for *pixel element*), and it's the number of pixels on the CCD that determines the camera's *resolution*, or how much detail the camera can capture. That resolution is measured in *megapixels*, which is short for *1 million pixels*.

To figure out the resolution, you simply multiply the number of pixels across the sensor by the number down. For example, if a camera has 1000 pixels across and 1,000 down, then it's a 1 megapixel camera, since $1000 \times 1000 = 1,000,000$.

Even Deeper (and Geekier) into an Imaging Sensor

Each pixel on the imaging sensor can record only a single color, but light is made up of many colors. The human eye sees all colors as a mixture of red, green, and blue. So right off the bat, there's a problem. Light is a combination of colors, but each pixel can only see a single color.

In order to get around this problem, a digital camera uses a neat trick. Each pixel can only "see" one color, but since the camera has lots of pixels, imaging sensors are designed using something called a *Bayer filter pattern*. This pattern creates the illusion that each pixel can sense every color. Here's how it works: The top

row of pixels on the sensor is laid out in an arrangement where the first pixel senses only red, then the next one senses green, then there's another red-sensing pixel, and so on, alternating every pixel between red and green. It looks sort of like a chess-board at this point. The next row down, however, uses a different arrangement where the first pixel is green and the next one is blue, so that this row alternates between green and blue pixels.

TIP

If you've already figured out that there are more green pixels than any other color on the sensor, then congratulations! That's because the human eye is most sensitive to green and the Bayer pattern attempts to compensate for that by providing more green-sensing pixels.

Remember that a pixel can only see one color, so when the shutter release button is pressed, each pixel on the sensor is missing information about the two other pixels. To fill in the gaps, the camera looks at the neighboring pixels and guesses what the other two colors should be based on the pixels that are nearby. The result is that each pixel reports its own color, plus the two guesses for the other colors.

So let's say I'm a blue pixel. When you push my camera's shutter release button, I look at the light hitting me and say, "Gosh, that blue light is about 80 percent as blue as it can possibly get." Then I turn to the red pixels all around me and say, "Hey, guys, how much red did you see?" Let's say the pixel above me saw 0 percent red and the pixel below me saw 100 percent red. Chances are, since I'm halfway between "no red" and "as red as you can get," I would have seen 50 percent red if I had been a red pixel.

Next I turn to the green pixels nearby and do the same thing. I look at the amount of green light all the pixels around me saw, and I guess what I would have seen if I were a green pixel.

Meanwhile, the red pixels are asking all their blue and green neighbors for their values while the green pixels are cribbing notes from the blue and red pixels. The result is a photograph made up almost entirely of guesses. Every pixel on the sensors has to guess what it *would have seen* if only it were able to see all three colors at once. For each pixel, then, one color is accurate and the other two are guesses.

When all is said and done, each pixel has a value for red, green, and blue. As a blue pixel, I might report, "I'm seeing 20 percent blue, and I'm guessing that I'm seeing 30 percent red and 60 percent green." My neighboring pixel gives his three values, and so on. Each pixel ends up with the three colors needed to create a picture, even though most of the information is made up.

The more pixels on the sensor, the more accurate this process is going to be. Why? Let's pretend that there is a dining room with a painting on the floor. I'm a blue pixel, so I look down and figure out how much blue is right under my feet. If my nearest green neighbor is 6 feet away on either side of me, I need to figure out what amount of green is under *my* feet based on what one green pixel sees 6 feet to my left and one sees 6 feet to my right. This could be accurate, but it doesn't seem too likely that I'll guess right.

If instead I place a green pixel 3 feet to my left and another one 3 feet to my right, there's a greater chance that my guess will be correct. (Instead of the two green pixels' being 12 feet apart, they are now 6 feet apart.) Put them a foot away from me, and things are looking better and better. If we stand shoulder to shoulder, we start to get really accurate.

This all happens pretty quickly inside your camera, and your camera probably does a very good job. But with all the guessing, sometimes the camera makes mistakes. The most obvious place digital cameras goof is around the edge of your subject where two different colors meet.

Think of a green mountain against a blue sky, for example. The pixels that fall along the edge of the mountain have to guess their colors based on their neighbors, but if there aren't a lot of pixels on the sensor, the closest green pixel on one side of the edge might be smack in the middle of the blue sky, while the closest one on the other side might be in a clump of trees. The pixels along the edge have to think really hard about what colors to be and so there's a lot of room for error.

A (MEGA)MILLION POINTS OF LIGHT

More pixels also mean better quality images, for a similar reason.

Let's think about that picture painted on the floor again. We pixels are responsible for translating that picture into a photograph, so we all look down and write down what we see, and we write down what the other colors are based on our neighboring-pixel guesses.

If the next nearest pixel is 6 feet away, we're going to miss any part of the picture that falls between us. There could be nothing there, there could be a splash of color—no way to tell. Make the next pixel 3 feet away, and the gaps in what we're seeing are much smaller, and so on.

As camera manufacturers figure out how to cram more pixels onto the same piece of silicon, the megapixel counts rise. The more dots on the sensor, the better the resolution of the photograph, and the more accurate the color rendition becomes.

A Fundamental Difference

So why did I wait until now to start to talk about megapixels? If you only plan to view your pictures on a computer monitor, even a 2 megapixel camera is enough. But if you plan to print your photographs, you'll need to think about resolution and understand the basic differences between the ways that a computer screen and a printer create pictures.

See Like a Monitor

The imaging sensor inside the camera is slightly smaller than a piece of 35 mm film, but to make things easier, let's just say it's an inch across and slightly less than an inch down. A 5 megapixel camera would squeeze about 2700 pixels across that sensor and about 1800 down, but for simplicity's sake let's say 2500 across and 1500 down. Let's also say that a 2 megapixel image would have 2000 pixels across and 1000 down.

In the same way that a digital camera sensor uses a series of pixels to capture an image, a computer monitor uses a group of light-emitting dots (also called *pixels*) to display the image. Just about all monitors, be they CRT or LCD (in other words, tubes or flat panels) show 72 pixels in every inch of screen. So you'd say that a monitor's resolution is 72 ppi *(pixels per inch)*, though many people call it 72 dpi (for *dots per inch*). (Note that as technology has developed, monitor resolution has gotten better, too. Many computer displays actually use a higher resolution than 72 ppi. This is a bit confusing, so we're going to stick with the 72 ppi standard in this chapter for simplicity's sake.)

TIP

It's not correct to refer to a camera's or monitor's pixel counts in "dots per inch," and hearing someone say it sends a shiver down the PhotoCoach's spine. Only a printer uses a dot instead of a pixel.

The image captured by the 5 megapixel camera would show up on the computer screen as being 34.722 inches across by 20.833 inches down *because 2500 divided by 72 is 34.722, and 1500 divided by 72 is 20.833*. Meanwhile, the megapixel image would be 27.778 inches by 13.889 inches *because 2000 divided by 72 is 27.778, and 1000 divided by 72 is 13.889.*

So the 5 megapixel camera creates an image that's about 7 inches longer than the 2 megapixel camera. Since no one has a 34-inch-wide monitor, it's not such a big deal. In order to display the pictures from either camera on a normal monitor, you'd have to resize it to be smaller anyhow (**Figure 8.3**).

▼ FIGURE 8.3: To display pictures from a 5 megapixel camera on a monitor, you'll need to resize them.

Think Like a Printer

Printers see the world a bit differently. First of all, they're snobs and they don't use the term *pixel*, sticking instead to *dpi*. Another strange thing is that printers have a different input resolution than output resolution.

A printer's input resolution is around 300 ppi. In other words, in order for the printer to create a photorealistic image, it needs four times as much information as does a monitor. A resolution of 720 dpi is considered the cutoff point for photo-quality output. Many printers have better quality modes, but this is the level at which a photo starts to look good on paper.

Why is it that a printer requires so much more image information? Because of the way that the human eye works, it only takes 72 pixels per inch on a screen to fool our brain into thinking that those individual dots are really a picture. The picture on your computer monitor is redrawn about 75 times each second, and that movielike effect is all it takes to get the optical illusion going. Something on a piece of paper doesn't refresh itself; we look at it much longer and more carefully. A higher level of detail is required in this case.

The output resolution for a printer is a measure of how many dots it lays down in a given inch. Check out the packaging for an inkjet photo printer (see "Getting a Good Print Requires a Good Printer," below) and you'll see large numbers touted for the device's resolution. It's not uncommon to see printers that are listed as being 1440 dpi, 2880 dpi, or even 5760 dpi.

In order to spray out any dots onto the paper, the printer needs an *input* resolution of around 300 ppi. The printer then mulls over those 300 pixels and figures out how to make the same picture putting down anything from 300 to 5760 dots per

inch in the same space. It's a great trick and requires very high quality images and very good photographic-quality paper.

A Numbers Game

So where is this all going? I started off telling you about the number of pixels on a CCD, and then I talked about the resolution of a monitor, and now we're talking about printers. Let's take a final look at some numbers to bring this all back together.

The image that started off on the 5 megapixel digital camera would appear on screen to be about 35 inches by 21 inches at 72 ppi. The 2 megapixel image would be about 28 by 14.

When that same image is printed out on an inkjet, we have to divide the original image size by 300 instead of 72, *because the printer's input resolution is 300 ppi and not 72 ppi.* So the 2500-by-1500-pixel image can print out at a maximum size of 8.3 × 5 inches. The 2 megapixel image can print out at a maximum size of 6.7 by 3.3 inches.

Inkjet printers have really improved in quality in a few short years, and they can now do much more with a lot less. Most high-quality inkjet printers have an input resolution that's closer to 200 ppi than 300 ppi, which means you can print a much larger image from the same photograph and still have great detail. Still, I'm sticking with the 300 ppi number in these instructions because it's a safe bet. If you don't know the input resolution your printer needs (which you can find in the manual), then 300 ppi will ensure that you've got enough detail to get the job done.

Let's say you have two cameras—one 5 megapixel camera and one 2 megapixel camera—and you use each to take an identical photograph. The 5 megapixel camera can take a picture that can be printed much larger than the one taken by the 2 megapixel

camera (**Figures 8.4a, 8.4b, 8.4c,** and **8.4d**). What's more, every few months, consumer cameras get increasingly larger sensors, and as a result they can create a much bigger photograph than a camera with lower resolution.

In order to print the 2 megapixel photograph as large as the one that came from the 5 megapixel camera, you'll need to enlarge it. When you enlarge a photograph past its maximum resolution, you end up making it less detailed. The 2 megapixel camera can't create a print that's as large as what the 5 megapixel camera can without losing detail and sharpness.

Getting a Good Print Requires a Good Printer

Just like you can't hop into a Pinto and expect it to drive like a Ferrari, you can't get good prints if you don't have the right gear.

- Make sure you buy an inkjet printer that will suit your needs. Look for the word "Photo" in the name of the printer model or on the box. Not all color inkjets are created equal, and a $30 printer will not give you high-quality prints.

- Look for a printer that uses six or more inks, as they produce more accurate color (**Figures 8.5a** and **8.5b**).

- Printer resolution is important, but for most people there's no visible output difference between a 1440 dpi printer or one that's 2880 dpi or higher.

- Use papers and inks that are recommended by your printer's manufacturer. While there are lots of third-party inks on the market, they aren't guaranteed to keep your printer healthy.

- A higher priced printer might not get you better images, but it will often come with added features, such as faster print speeds or a larger variety of acceptable papers.

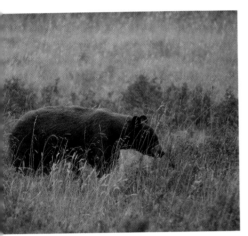

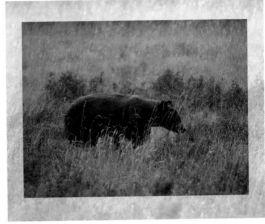

▲ **FIGURE 8.4A:** A photo of a bear taken with an 8 megapixel camera can be printed at quite a large size without becoming blurry.

▲ **FIGURE 8.4B:** The same photo taken with a 5 megapixel camera can still be printed at a decent size, but not as large as with the 8 megapixel camera

▼ **FIGURE 8.4C:** The bear photo taken with a 3 megapixel camera prints noticeably smaller than one taken with an 8 megapixel camera..

▼ **FIGURE 8.4D:** And when taken with a 2 megapixel camera, the bear prints at the smallest size of them all.

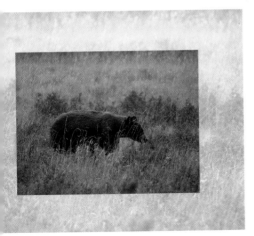

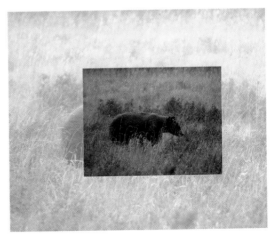

▲ **FIGURE 8.5A:** The Epson Stylus Photo 960 uses six color inks.

▼ **FIGURE 8.5B:** The Epson Stylus Photo 2200 uses even more color inks—seven total.

Ready, Set, Print

OK, enough with the theory. You're interested in printing your pictures, and I can't blame you.

In addition to needing an understanding of resolutions to discuss maximum image size, you'll need the same information to figure out how to resize your photograph in order to print it.

If you use an all-in-one program such as Apple's iPhoto or Adobe Photoshop Album to store and print your photographs, the software will automatically resize your images when you output them to an inkjet printer, and it will warn you if the size you've chosen enlarges the image so much that it will lose detail (**Figure 8.6**).

If you use a photo-editing program such as Adobe Photoshop Elements or Jasc Paint Shop Pro you'll need to resize the image before you print it (**Figures 8.7a** and **8.7b**).

▼ **FIGURE 8.6:** All-in-one programs such as Adobe Photoshop Album will automatically resize your images and will even warn you if the size you've chosen will result in a low-resolution image.

▲ **FIGURE 8.7A:**
In Jasc Paint Shop Pro you choose the image you want to resize and then select Resize from the Image menu.

▼ **FIGURE 8.7B:** In the resulting dialog, you simply change the print size to the width, height, and resolution you want.

Here are the steps for resizing an image in Photoshop Elements:

1. Open the photograph you'd like to edit.

2. Choose Save As from the File menu, and save the photo with a new name. (If your photo isn't saved in the JPEG format, do so now by choosing JPEG from the Format pull-down menu.)

3. Choose Image Size from the Resize submenu of the Image menu.

 The Image Size dialog will appear with the image's resolution in pixels provided in the top box and its size in inches (at the selected resolution) listed at the bottom.

4. You can either change the pixel information in the top section to match what you need, or change the height, width, and resolution in the bottom section.

 To use the top section, you'll need to do all kinds of math, so it's easier to just plug in numbers in the bottom section.

5. Enter the size you'd like the printed photo's width to end up (in inches) in the width box. Notice that the height field automatically changes to the correct value.

6. Next, change the resolution. A safe bet is to select 300, but some great inkjet printers operate well at a lower number. Use the number in your manual.

7. Click OK.

8. Save your photo.

9. Select Print from the File menu. See "Sooo Many Options" below for information on the printer dialog.

Images from most digital cameras open up at 72 ppi, and you'll want to resize them to your print input size at 300 ppi (or whatever number your printer's instruction manual recommends). If you just enter 300 *without changing the size of the height and width* in the dialog, you'll end up with a photograph that's 34 inches wide *and* 300 dpi. That will be one huge photo.

TIP

A calculator will help you do the math in order to figure out the maximum size you'll need, but if the print you're making is smaller than the maximum size image your camera can create—for example, if your camera creates an image that's 8 inches wide at 300 ppi but you're only printing at 4 inches wide—you can just enter the height and width information, and change the 72 ppi setting to 300 ppi (again, or whatever your printer manual recommends). For example, if you want to print a 5 megapixel image at 4 inches by 6 inches, just put in *4* for the height, *6* for the width, and *300* for the pixels/inch.

Gotta Look Sharp

Resizing an image to be larger than the maximum size causes the image to lose detail, but resizing it to be smaller than its original size introduces a little bit of blurriness as well. The effect is caused by all the pixels being squished together in the smaller space.

Before you print your image, you'll want to sharpen it a little bit to counteract this effect. There are a few different ways to add sharpness back into your image, but the simplest is to use your photo-editing program's *sharpen* filter. In Photoshop Elements that's done by choosing Sharpen from the Sharpen submenu of the Filter menu (**Figure 8.8**). Generally, running the sharpen filter just once does the trick, although on occasions you may need to run it more than once.

▼ **FIGURE 8.8:** The easiest way to make your image as sharp as possible is to use your photo-editing program's sharpen filter.

Professional photographers use a tool called the *unsharp mask* to add sharpness. It sounds as if the filter would add blurriness, but it's based on an old darkroom technique where a bit of the image is covered, or *masked*, to sharpen a picture. You can experiment with the unsharp mask, but it's more difficult to master than the sharpen filter (**Figure 8.9**). It's also more powerful because it sharpens areas that traditionally lose detail and leaves other areas alone. The sharpen filter applies sharpness to everything.

▼ **FIGURE 8.9:** Professional photographers use the unsharp mask tool to add sharpness, but it is harder to master than the sharpen filter.

Sooo Many Options

When you finally click the Print button, a dialog pops up giving
you an overwhelming number of options from which to choose.
Every printer brand and model has its own dialog with an array
of possible print settings.

While you are becoming familiar with your color printer, it's
a good idea to start off using the default settings for your paper
type. In the Print dialog, look for the Print Settings choice from
a drop-down box. Different printers might call this screen other
things, but it's the location where you can select paper type,
printing mode, and print quality (**Figure 8.10**).

▼ **FIGURE 8.10:** The Print dialog is where you select things like paper
type, orientation, and print quality. The Print dialog in Jasc Paint Shop
Pro is shown below.

On a plain paper setting, most printers will default to normal quality and 720 dpi. Selecting a better paper type will cause the printer to automatically select the settings that match the optimum output for that printer. This is another reason to stick with the papers provided by your inkjet manufacturer: You can simply select the paper type and have the best-looking output pop out of your printer moments later.

The Print dialog also contains choices for individual color adjustments, modifications to brightness and contrast, and so on (**Figure 8.11**). Print out a sample of your page and see if it looks right using the default settings. If you're unhappy with the output, try to modify some of the settings in the dialog and then print another page. When you print another image, repeat the same test to see if those modified settings make your photograph look better than the default settings. If they do, you can save those settings to use in the future.

Finally, the Print dialog will include some sort of cleaning or maintenance option. Inkjet printers are very sophisticated pieces of equipment, but sometimes they produce less-than-optimal output. If inkjet printers sit too long without being used, their nozzles can clog up. Use your printer's head-cleaning utility to clean the print heads. You may have to run the cleaning routine several times.

Check your printer's owner's manual to find out how to run the head-cleaning utility. Some printers have a button (or combination of buttons) that triggers a clean cycle, while others use a software utility to send a command to the printer.

▲ **FIGURE 8.11:** Advanced settings in the Print dialog give you much more flexibility over your print. Because there are so many options, however, you'll have to do some experimenting.

Fancy Printing
Making creative custom prints

If a big part of the fun of digital photography is that you can easily print your own pictures—and do it with so much creative control—that fact is no less true for a professional photojournalist like Michael Schwarz.

About 10–15 percent of his freelance business comes from photographing weddings, which he shoots in a documentary style similar to the way he shoots stories for his magazine clients. Schwarz offers his wedding customers several print packages, but his basic package includes 4-by-6-inch prints of most of the shots from the wedding—typically 800–1200 prints—that he has made at a local digital photo lab.

"Then I ask them to pick their 12 favorite images from that group of pictures," Schwarz says. "I don't tell them what I'm going to do with the images. I just ask them to pick them out."

Schwarz makes custom prints of the selected shots with his own printer. "I make two to three different versions of each picture," he says. "I try to do something that's unexpected, something that they've probably never seen before. I might make the print on special fine-art paper. I might make it black and white. I might make part of the picture black and white and part of it color. I might put a special border on it. Sometimes I do a combination of those things, depending on the image itself. It's up to me to be creative." But on the creative front, less is often more, he cautions. "Digital allows you to do so many things so easily, you have to be careful to avoid the temptation to do too much, to do too many effects."

The prints Schwarz typically makes vary in size from a 6-by-9-inch image on letter-size paper to a 10-by-15-inch image on 13-by-19-inch

paper. (In other words, he leaves a large white border.) A big part of the appeal of these enlargements is the unusual papers he often prints them on.

Schwarz likes two particular specialty fine-art inkjet papers: Hahnemühle Photo Rag and Epson Velvet Fine Art. "The Epson Velvet paper is very thick," he says. "It has a rough surface with lots of texture. It's very fibrous, and it seems kind of soft. The inks absorb down into the paper surface, and it's just a really beautiful paper with beautiful colors. It gives you almost a painterly look."

One recent wedding he photographed offers a good example of what he does. The couple liked one shot of themselves together, with the bride holding her bouquet. Using Adobe Photoshop, Schwarz began

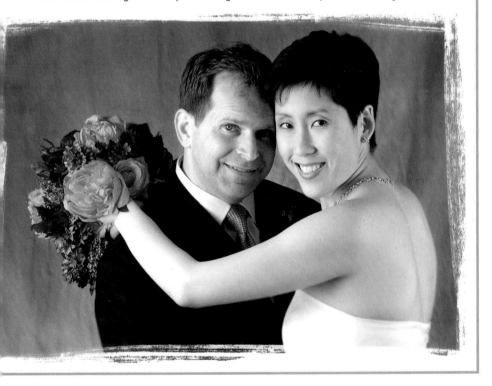

playing with the image. "I converted it to black and white," he says, "but then I brought the color back in the bouquet. So I've got a picture that's primarily black and white, but it has this splash of color. After I did that, I slapped a border on it with Extensis PhotoFrame." He printed the picture on Epson Velvet Fine Art paper and presented it to the clients. "They loved it. They'd never seen anything like it."

"The Epson Velvet paper is very thick. It has a rough surface with lots of texture. It's very fibrous, and it seems kind of soft. The inks absorb down into the paper surface, and it's just a really beautiful paper with beautiful colors. It gives you almost a painterly look."

Equally important, it won't fade anytime soon. Schwarz uses an Epson Stylus Photo 2200 printer to make his prints, and its UltraChrome inks, when used with the Velvet Fine Art paper, produce prints that should last up to 60 years if properly handled. "So you're giving them a wedding shot," Schwarz says, "that will last the lifetime of the client. Longer than a print on photo paper."

—EAMON HICKEY

How to Take a Great Family Photo

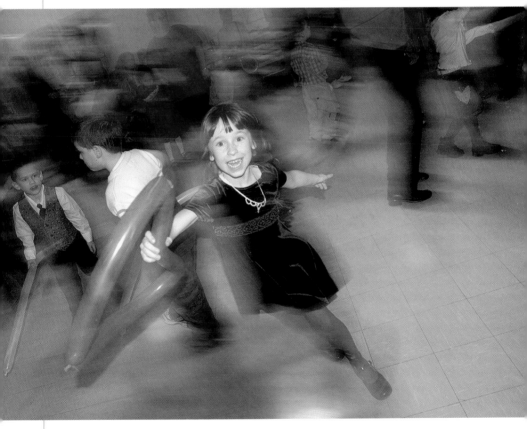

Smile!

Or Else.

ASK JUST ABOUT anyone who has purchased a camera in
the last, oh, let's say 100 years or so what he or she uses
the camera to take pictures of, and odds are that the
answer will be "My family."

Just flip through the pages of someone's photo album or dig
though an overflowing shoebox of photos and what do you find?
Rarely do you see hundreds of images of someone's car or soccer
ball. Instead there are piles and piles of photographs of family
members (**Figure 9.1**). There's an almost instinctive need to
photograph family events, some primal urge to document and
protect a memorable event, like a caveman painting on the walls.

It's a shame that most people's family pictures are so awful.

We've seen it all. Heads cropped off on the top of the frame,
blurry family members, thumbs over the camera lens, and eyes
so red the picture looks like a meeting of demons rather than
kids enjoying a birthday party.

By and large, the problem is that most family photographs are
snapshots, a term coined by photographers to refer to any photo-
graph taken without much thought as to how the picture is going
to look. Most of the time people just point their cameras at their
subject and press the button, ending up with a photograph that's
not well composed and doesn't put the subject in a good light.

Or, even worse, the opposite happens and the photos are over-
posed, leaving people looking like weird robotic versions of
their real selves. When's the last time someone walked up to you
and said, "Say cheese!" when you *weren't* in a photograph? If
you've ever had to wait with a fake smile frozen on your face for

someone to *finally* take the picture, you know what we mean. If it doesn't happen in real life, maybe it shouldn't happen in a photograph either.

Luckily, the PhotoCoach is here to help. I'll show you ways to take great pictures of your family so that your photographs are more exciting and interesting, and better than ever (**Figure 9.2**).

▼ FIGURE 9.1: Flip through most people's picture albums and you'll find a wealth of old family photos.

▼ FIGURE 9.2: With the help of your PhotoCoaches you'll be able to take more interesting photos of your family.

Better Family Pictures: the Easy Way

When it comes to taking family pictures there are a few simple things to keep in mind:

- Make sure your subject is comfortable.

- Make sure your background isn't too distracting.

- Make sure your picture says something about *why* you are taking the picture in the first place—you want the photograph to communicate something to the viewer about the subject.

Getting to Know You

The best photographs are taken when the subject is comfortable and at ease. People who like having their picture taken are going to look better in the photo than people who don't—it's that simple. Most pros work very hard to try to get the people in their pictures to loosen up enough to have a good time so that they don't look stiff and posed.

TIP

Telling people to "say cheese!" has never, ever made them more comfortable. Only the Swiss are comforted by cheese.

You, however, have an advantage over professional photographers because your family members should feel at ease being around you. (If they do not, perhaps you might want to take a trip to the self-help section of the bookstore for a copy of something to supplement this chapter.)

Posing your family in awkward situations (who really stands around with their arms behind each other's backs anyhow?) and forcing them to smile only breaks down that comfort and makes

people feel silly. You can tell this because the second the photo-
graph is over, everyone scurries away (**Figures 9.3a** and **9.3b**).

Sure, there are times when you'll want a formal group photo-
graph in order to document who attended the family reunion
or exactly who made it to your daughter's birthday party. But

◀ **FIGURE 9.3A:** Here's the type of
awkward shot that most people get
when forcing their family to stand
still for a photo.

▼ **FIGURE 9.3B:** But photos of your
family don't have to be dull and
uninteresting. It's easier than you
think to create fun images such as
this one.

gathering everyone as if they were in a police lineup and forcing them to look happy is never going to result in a good shot.

Instead of asking your subjects to smile for the camera, talk to them. When people talk about something that interests them, they automatically smile. Instead of a "canned" or fake look, you'll get a genuine show of teeth.

TIP

Trying to get a whole group of people to look good at the same time? Take a tip from your PhotoCoach and talk to individuals in the group. "That's a great-looking dress, Grandma!" not only will make her smile, but it will make everyone else smile, too. Say something funny and lighthearted and you'll get a great reaction from the whole bunch.

Professional photographers have a secret weapon in the battle to relax their subjects: the power of touch. Simply putting your hand on the shoulder of a subject relaxes him or her—strange but true. Photographers posing people will often create reasons to make contact with their subjects. Likewise, straightening a tie or fixing a shirt collar unconsciously tells your subject that you care about how he looks. Find or make up a small problem (you don't want them thinking that they have been looking really silly all day) and adjust it with a "There, you look perfect!" and anyone will be happy to have her picture taken.

Remove the Clutter

Another easy way to improve your family photographs is by improving your background. We're not talking about getting a degree from a good college here, but rather about eliminating distracting elements from your photographs.

Many family pictures are taken at big events; parties, trips, school ceremonies, and weddings are great times to break out the camera. But they also tend to have really distracting things going on. Think about your average birthday party with balloons, children running in circles, and maybe even a clown. Or how about a trip to Niagara Falls with the great cascading water and hundreds of other tourists milling around? Maybe you're shooting at a graduation, where hundreds of students are gathered wearing identical caps and gowns.

Each of these situations has the potential to overwhelm your photograph. Try to take a picture of your family against a background of colors and motion and you'll end up with a picture in which it's hard to focus on the subject.

There are two ways to handle this situation and end up with a better photograph. One involves the camera; the other involves your creativity.

CHANGING THE CAMERA'S MODE

The aperture you choose affects the look of your photograph. It's a good idea to understand how your camera's aperture works.

All cameras have a small hole that lets in light in order to make a picture. This hole is called the *aperture*, and it's one of the most important things to know about your camera. Changing the size of the hole changes how much light gets through. When the

hole is smaller, less light gets through, and when it's larger more light gets through.

When the hole is larger, light can also get into the camera from more angles, making the background look blurry. When the hole is smaller, only light coming from straight ahead can make it into the camera.

The smaller the hole, the more of the background is in focus. This is called *depth of field*. Another way to think of depth of field is as a way to refer to how much of the background of your photo is in focus. A shallow depth of field has only the close objects in focus. The greater the depth of field, the farther back or forward objects can be and still be in focus.

For reasons you don't have to bother with, the size of the hole is also called the *f-stop*. Confusingly enough, the *smaller* the opening is, the *larger* the f-stop number, and those numbers relate to the amount of light making it into the camera. So, a camera with the hole all the way open might be "at f/2.8" (pronounced "ef-two-point-eight"), while one with the hole as small as it can get (and still let light in) might be "at f/45."

There is much more depth of field at f/45 than at f/2.8. Almost all digital cameras give the user some sort of control over the aperture setting. If your camera has Aperture Priority mode or Manual mode, it will let you change the aperture through a menu item, or else you can use the camera's buttons (usually a rocker switch on the back or a finger dial near the shutter release) to change the f-stop setting. If you're trying to eliminate a distracting background, go for a smaller number for your f-stop setting (f/2.8 instead of f/16, for example).

TIP

If you use too large an aperture (a low f-stop number) and your subjects are at different distances, they might not all end up in focus. It's a game of trial and error. But hey, with a digital camera, you can take as many photos as you want and just erase the bad ones.

Some cameras don't have a Manual or Aperture Priority mode but instead have preset *scenes*. Change to the Sports mode and the camera changes its settings to capture high-speed motion. Switch your camera to Portrait mode and the f-stop will automatically be changed to a low value.

Either way you change your camera's settings, the end result is the same—you'll get a photograph of your family with them in

▼ **FIGURE 9.4:** A blurry background lets you focus in on the subjects that are really important—your loved ones.

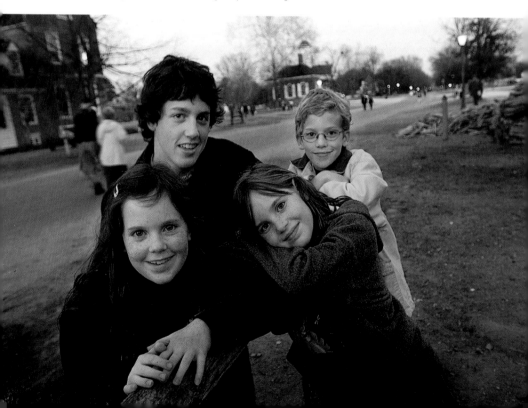

▲ FIGURE 9.5: Here a plain background is used to cleverly frame the kids and their poses.

perfect focus and the background blurred enough to remove the distractions (**Figure 9.4**).

CHANGING YOUR MODE

The other way to get rid of a distracting background is to move your subjects around. This seems like it might be the easier solution (and many times it is), but often breaking up the action in your photograph to move someone around kills the spontaneity you worked so hard to encourage.

A great background is one that lets the photo viewer know where the action took place, without the background jumping out as the subject of the photo (**Figure 9.5**). For example, a graduation photograph taken in front of the distinctive columns of the school's library would have a better background than one shot in the parking lot of the school. (Unless of course someone in your family graduated from auto repair school.) Don't, however, force your subject to move to a better background. Point out a nice backdrop for the photo and say, "You'd look great in a photograph in front of that waterfall!"

◀ FIGURE 9.6A:
Taking photos of
people when they
aren't aware of it
can produce stun-
ning results.

Focus on the Moment

Think about why you are taking pictures of your family in the
first place. What is it that you want to capture?

For most people, photography is a way to preserve the memories
of time spent with the people closest to you. From baby pictures
to portraits of great-grandparents, family photos are important
because they say something to you about your subject.

But when you think about someone in your family, it's a good
bet that in your mind you picture him or her somewhere familiar.
You might picture your grandparents in the kitchen making their
famous holiday dishes. Or maybe you think of your daughter
playing on the swings at the park.

The best photographs of your family capture them the same way. By photographing your family doing what they love to do, where they love to do it, you're guaranteed a better shot (**Figures 9.6a** and **9.6b**). Also, try not to interrupt something like your family's Thanksgiving dinner to take a group photograph. Instead, take pictures of everyone eating, smiling, and having a good time. It might mean that you'll have to keep your camera handy all through the meal, but that's the way you'll get the best shots. Most people pick up their camera to take a few posed shots and then put the camera away. By keeping the camera handy, you're more likely to capture a photograph that will really look great.

▼ **FIGURE 9.6B:** Likewise, if you photograph people doing things they love to do or naturally do, you'll end up with a great candid shot.

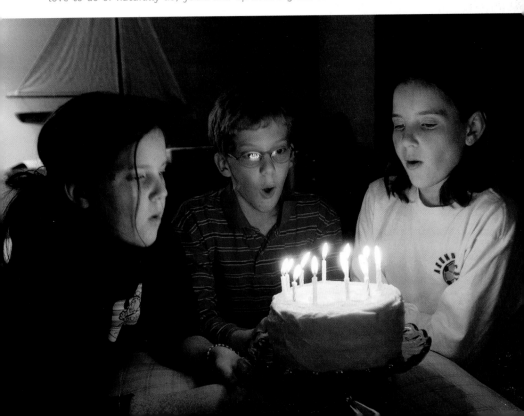

The Art of the Formal Portrait

The forced-smile group photograph we talked about earlier has its roots in the history of photography. From the 1800s to the early 1900s, taking a photograph required coating a sheet of glass or paper with a chemical mixture by hand and then making an exposure of several minutes to capture an image. Because of the long exposure times, subjects had to sit very still to make sure the final picture wasn't blurry. With the process being so complicated and so expensive, no one would risk ruining a shot by photographing a moving subject.

Even though technology has vastly improved over the last hundred years (most cameras can easily take a picture in 1/4000 of a second or faster), we still take portraits the same way. We line people up, make them stand still, and take their picture. It might not make sense but it's tradition, and traditions are hard to change. It would be hard to imagine a formal event such as a wedding or a prom without a portrait photographer.

Those portrait photographers spend a lot of time honing their skills in order to get an image that captures someone's likeness and is artistic as well (**Figure 9.7**). The Blue Pixel team has taken portraits of everyone from sports figures to CEOs, local politicians to the president. Here are some top ways to take a great family portrait.

Setting the Mood

Take a look at really good portraits and you'll notice something they have in common: No matter who the picture is of, it conveys something about the subject. Even if you don't know who the person in the photograph is, you should be able to look at

▲ **FIGURE 9.7:** Professional portrait photographers are experts at capturing both people's faces and their personalities. You can do the same.

the portrait and instantly understand something about him. The *mood* of the photo should be in keeping with his personality.

A portrait of a woman wearing a tutu in a ballet studio immediately lets you know that the person you're looking at is probably a ballerina. Likewise, a man in a suit sitting in a corporate boardroom is probably a CEO or some other executive (**Figure 9.8**).

▲ **FIGURE 9.8:** Background and lighting can tell you a lot about a person. Here it's pretty obvious that the subject is a businessman or executive.

Does your dad love to write music? Set the mood by taking a portrait of him at his piano. With a formal portrait you're more likely to tell your subject how to sit and behave, but it still works best to let him be spontaneous and free about the poses. You might want to give him some suggestions, maybe ask him to play a song for you on his piano, and while he's doing that you might suggest he lean over the keyboard and write notes on the sheet music.

The PhotoCoach likes to experiment with angles, too. It's not just a myth that some people have a "good side" in a photograph; some people just look better in a picture when photographed a

certain way. Move around your subject looking for great views (**Figure 9.9**). Try shots from the front, from the side, or even from the back!

TIP

If someone doesn't like a suggestion for a pose, don't force him to do it. A photograph is forever, and no one wants to be remembered doing something he thinks is embarrassing or unflattering.

To set the mood, you should also try to make your photograph reflect the personality of the subject. You should take a different portrait of someone serious than you would of someone humorous. Your funny uncle, the one that always does card tricks and pulls pennies out of people's ears, would look out of

▼ FIGURE 9.9: Just a straight shot of this man would not have been nearly as interesting as it is taken from this angle.

▲ **FIGURE 9.10:** Serious portraits usually feature more shadows than lighthearted ones have.

place in a portrait where he was frowning. But a portrait of your other uncle, the one that always told you to stop jumping on the couch and chases kids off his lawn, would look strange if he were all smiles.

Some photographers will mix things up by putting a funny person in a serious pose or vice versa. This is usually done with celebrities who are well known to play with our perceptions of those people. When it works, it works well. When it doesn't work, it doesn't work at all.

Light It Up

In photography, lighting is key. While some artists work with tubes of paint or with clay, many people say that photographers work with light.

This is especially true for a formal portrait. You might not have the same expensive lighting gear that the PhotoCoach has. Being a professional photographer, the 'Coach spends a lot of time dragging heavy lighting gear all over the country. You don't have to hire an assistant to tote your gear around in order to get a great shot, but you can still work with light to make your portraits better.

A portrait should be lit in a way that matches the mood—a serious portrait will often be darker and feature more shadows than a lighthearted portrait (**Figure 9.10**). You can use available light to illuminate your subject (windows and daylight are a favorite choice), or you can use an electronic light source such as lamps or your camera's flash (**Figure 9.11**).

▼ FIGURE 9.11: Even though the background in this photo is dark, the kids' faces have been lit well to portray a lighthearted mood.

Different light sources have different "colors." The light that comes from a household light bulb is a bit yellow, while the light from a camera flash is a bit blue, and fluorescent bulbs produce light that's a bit green. This is a problem for film cameras, because film is "balanced" for one type of light. (Light from that particular source looks white, but all other light will have a color.) With digital, though, you can set the camera to balance itself to any type of light on any shot.

Great portraits have been made with clusters of house lamps, handheld work lights, and all sorts of strange gear. Experiment with your lights, and see what kinds of shadows and highlights are created as you move them around. The PhotoCoaches use reflectors to point light to important areas of the photograph, and big sheets of foam or other material to block light from other areas. You can make these yourself with pieces of foil.

If your camera has a flash, you'll want to know when to use it and when not to use it. If you're setting up a moody portrait using household lamps and your flash goes off, the light will overpower the lighting setup. On the other hand, if your subject is lit from the back, you might want to add some flash to "fill" in the photograph.

Also when it comes to light, remember that the sun is your friend. That is, unless it's directly behind your subject. Nothing ruins a good picture better than a blindingly bright sun over someone's shoulder. The light is just too bright for the camera, and the person in the photo ends up with a face obscured by shadows. Turn your subject so that the sun strikes her from the side or the front for a better picture.

Photographing Your Children
(if Only They Would Sit Still)

Children and babies are both the hardest and the easiest subjects to photograph. They move around, they fidget, they squirm, but they just look soooo cute.

Some professional photographers make their careers out of photographing children—it takes a certain knack to get them to sit still and look good. Others refuse any job that involves kids.

Obviously, you don't have that choice, and really, how can you resist photographing those cute kids of yours?

All of the things we've talked about so far apply to photographing children: Don't try to force them into a pose, capture them doing what they love best, and make them comfortable. Only with children it's doubly true.

▼ FIGURE 9.12: Try to capture the cuteness of a baby. Photographing them from above provides a natural angle since that's how adults generally view them.

Goo-Goo, Ga-Ga: Taking Pictures of Infants and Toddlers

Generally speaking, babies and infants look cute—otherwise, who would put up with all the crying and the diapers? The only photograph of a baby that looks outright *bad* is the over-the-crib shot so popular in the maternity ward. The babies in them look more like aliens than people, and the pictures usually make people cringe. The problem is that the bird's eye view is an unflattering one for anybody and the lighting in these pictures is terrible.

If you *must* do the crib shot, take the photograph from the baby's side or through the bars. You'll still get a photograph of a sleeping child, but one without the Mr. Potato Head angle. But a better idea is to take a photograph that really shows off the cuteness of a baby (**Figures 9.12** and **9.13**). Nestled in the comforting arms of their mother, being adored by a grandparent, or sitting on the floor propped up on their baby arms makes for a great shot. Other than the maternity ward crib shot, however, photographing a baby from above is a good angle. That's because most people view babies from slightly above—it's a natural way to look at a baby and it doesn't make the baby's features look strange.

Babies' faces are fascinating. It's easy to just stare at the face of a newborn and look at him learning how to smile, frown, and giggle. Capturing these expressions leads to great results.

▲ FIGURE 9.13: No doubt about it—babies are cute. Your photos of them should be, too.

▲ **FIGURE 9.14:** When taking a photo of a baby, it's a good idea to get in close enough that the baby fills the entire frame of the picture.

Composition is especially important in baby photographs because babies are so darned small. A common mistake is to photograph a baby from the same distance as you'd take a picture of an adult. But babies are teeny, so get in close and take a shot of them that fills up most of the frame and isolates them from the background (**Figure 9.14**).

TIP

While it might be really cute, photographing your infant in the tub with some infant friend will only serve to embarrass your child later on in life. Of course, that's enough reason for some people to take a photograph.

Come Back Here! (Photographing Children)

From toddler through teenager, it gets progressively more diffi-
cult to take a portrait of your kids. But that doesn't mean you
should put away the camera. Young kids will sometimes sit for a
photograph because they enjoy the attention (**Figure 9.15**). And
as kids get older, there are still plenty of ways to get a great
photo. Let your PhotoCoach show you what to do.

▼ **FIGURE 9.15:** As your child grows, you'll want to catch those
special "firsts," such as that grin after the first tooth falls out.

When you're doing something with your children, experiment with lots of different angles and compositions. Take wide-angle shots and close-ups (**Figure 9.16**). Take pictures with lots of action, and shots when your kids are resting.

Shoot your pictures at eye level with your kids for better photographs. Otherwise you'll have lots of pictures of the tops of little heads. Things look different when you're 3 feet tall. Show the world from a kid's-eye view for a better picture (**Figure 9.17**).

◄ **FIGURE 9.16:** Nothing can capture the sweet faces of children better than close-ups.

▲ **FIGURE 9.17:** You should always feel free to experiment with photos taken at different angles, but when it comes to kids, it's always a safe bet to take a photo at eye level.

But this is also a time when it becomes easier to take pictures because your children will pick up hobbies and activities as well as go through different stages of growth. Now is the time to fill up your photo albums with pictures of your children playing soccer, marching in the band, fishing, and so on (**Figure 9.18**). Photography is all about memories, and this is when some of the best memories are found.

TIP

Want to get your kids interested in having their photograph taken? Let them see the camera. Take advantage of having an LCD screen on the back of your camera and show them how they look between shots. It'll make the shoot more interactive and keep them involved in the process.

▲ FIGURE 9.18: Older children start to take up hobbies and sports—catching them doing something they enjoy always makes for a good photo.

Who Wants Their Picture Taken?
Yes You Do! Yes You Do!
(Photographing Your Pets)

Make no mistake about it—pets are part of our families. The furry, feathered, and scaled menageries that share our homes are part of our lives.

Photographing your pets uses skills similar to those used in baby photography, since pets can't speak. It's impossible to explain to Rover that you'd like a portrait of him for the family album. Unless your camera looks and smells like a big bowl of kibble, he's not going to pay attention to it (**Figure 9.19**).

▼**FIGURE 9.19:** Snap your fingers at the camera to get your dog to look at the lens.

Dogs are your best bet for a formal portrait candidate, as they will tend to "sit" for a longer period of time. If you want them to look directly at your camera, try snapping your fingers in front of it. Other pets are trickier to photograph, and it's best to just try to catch them when they are in the middle of doing something interesting (**Figure 9.20**).

▼ FIGURE 9.20: Some pets just won't pose for you. It's best to catch them doing something natural.

Documenting Your Family's Life

Photojournalists (the people who take the pictures you see in newspapers and magazines) have a different approach to photography than portrait photographers do. To a photojournalist (called a "PJ" in the business), everything is a documentary happening in real time. Instead of looking to capture the most flattering view of an event, a PJ strives to capture the most realistic view, blemishes and all.

This isn't always the most flattering way to photograph your family, but in some situations it can result in truly amazing photographs. Documentary photography works best in capturing a special event or period of time when a family or a family member undergoes some changes.

Take a wedding, for example. Years ago a wedding photographer would only take posed pictures of the bride and groom and their families during the ceremony and just afterward. Many photographers now start hours before the wedding itself, photographing the bride and bridesmaids as they prepare for the big day. Instead of photographing just the bridal party, the photographer will take behind-the-scenes photos of everything having to do with the wedding (**Figures 9.21a, 9.21b,** and **9.21c**).

This style of documentary photography is great for lots of other subjects too. Think about the things you'll want to remember in vivid detail years from now. Maybe you're going on a family vacation, and instead of only photographing the kids standing in

▲ **FIGURE 9.21A:** Every wedding album should include good group photos of the bridal party.

front of the Grand Canyon, you take pictures of them as they prepare for a day of hiking, then as they settle into a campsite at the end of the day.

Even if you're not photographing a specific event, using a documentary style of photography means that you'll have cherished memories of your family members as they grow up, grow older, and grow closer. With a digital camera you keep taking pictures without worrying about wasting film. Just try to find new and interesting ways to look at everything. And keep taking pictures.

▲ **FIGURE 9.21B:** Don't forget the candid shots, however...

▼ **FIGURE 9.21C:** ...or the ones behind the scenes.

The First Family
Even the pros can get nervous sometimes

As your PhotoCoach says, the power of touch can be a great way to relax your subjects, but what happens when you're the nervous wreck? Kevin Gilbert knows the answer.

In 1986, he was a 27-year-old junior staff photographer for *The Washington Times* when the newspaper's managing editor was invited to do a one-on-one interview with President Ronald Reagan in the Oval Office. Gilbert, to his surprise, was assigned to shoot the picture that would be published alongside the interview.

"I'd been to the White House before," Gilbert remembers, "but not to the Oval Office and never close enough to hear the president breathe. Rookie photographers don't often get the chance to do that kind of thing. You have to earn your stripes. So I was pretty nervous about it.

"Now the lighting in the Oval Office is pretty strange," he continues. "It's actually three different types of light, including fluorescent and incandescent. The color balance is really tricky. So I decided to set up my own flash." His flash would overpower the Oval Office's existing lights and prevent the green and amber color casts that those lights would have produced in his pictures, Gilbert explains.

"I got to the White House early to set up my light before the interview began, and one of the president's press aides said he would take me into the Oval Office. I figured the office would be empty. That's the way it always works. You set up your scene, and then some people walk in the movie star or the politician or whoever, you take your shot, and then they walk the person back out again."

The press aide took Gilbert into the office, pointed out the couch where the interview would take place, and then left. "Now that office

is so big," Gilbert continues, "that I didn't notice at first that I wasn't alone. But then I realized that Reagan was actually in the room. He was sitting at his desk signing papers. It's just me and him. All I can remember thinking is, 'Don't look at him!' So I kept my back to the president, but I'm hearing every breath he takes.

"Now, photojournalists have to be quick and efficient. It took me maybe 2 minutes to set up my light," says Gilbert. He was using one external flash mounted on a light stand with an umbrella, which would soften the effect of the flash. "So after I've got it set up, I don't know what to do. Should I leave? Go back out into the hallway? I don't even know how to open the door," says Gilbert. "I ended up staying right where I was and checking my camera and my light about eight times just to look like I was doing something. It was just nervous energy.

"So I'm standing there pretending to be checking my stuff, and suddenly I feel this big hand on my shoulder, and I hear, in that

"But then I realized that Reagan was actually in the room. He was sitting at his desk signing papers. It's just me and him. All I can remember thinking is, 'Don't look at him!'"

famous voice of his, 'Well, are we ready yet?' I was startled—here's the president of the United States with his hand on my shoulder!—and as I turned toward him, I bumped my light stand over. I caught it just before it broke this lamp that was sitting on an end table. He just kind of chuckled, and I said something like, 'We're all set, sir.'"

Now that the ice—and luckily not the lamp—was broken, Gilbert relaxed and quietly made his pictures of the interview that followed. One of the shots ran on the front page of the *Times* the next day.

—EAMON HICKEY

How to Take a Great Sports Photo

Get the Competitive Edge

with Your Action Shots

Take me out to the ball game, • *Take me out to the crowd.* • *Take me*
some pictures of Little League, • *My kid out there, he is getting so big,* •
So it's shoot, shoot, shoot for the album, • *If the pictures suck it's a shame.*
'Cause it's one, two, three megapix' • *At the ol' ball game.*

AFTER FAMILY FUNCTIONS, perhaps the most commonly photographed event is the kids' sporting match. (The school play is another favorite though less common subject.) Action-based photographs are thrilling to look at but often difficult to capture (**Figure 10.1**). The fast motion of most sports seems hard to predict, and harder to photograph.

▼ **FIGURE 10.1:** Action photos can be hard to capture without introducing blur.

Taking photographs of your family's adventure travel is no better. You'd like to capture the family on a nice bicycle outing, but how exactly do you get a photograph while riding your bike?

Often if the photograph you take isn't blurry, then it doesn't convey any sense of motion or excitement (**Figure 10.2**). Sports photography can be tough if you don't know the tricks of the trade. Luckily the PhotoCoaches have taken their share of photos of everything from soccer tournaments to mountain bike races. Here are some of the techniques the pros use to capture priceless sports photos.

▼ FIGURE 10.2: Sports photos that lack blur can sometimes look as though the subject is not moving at all.

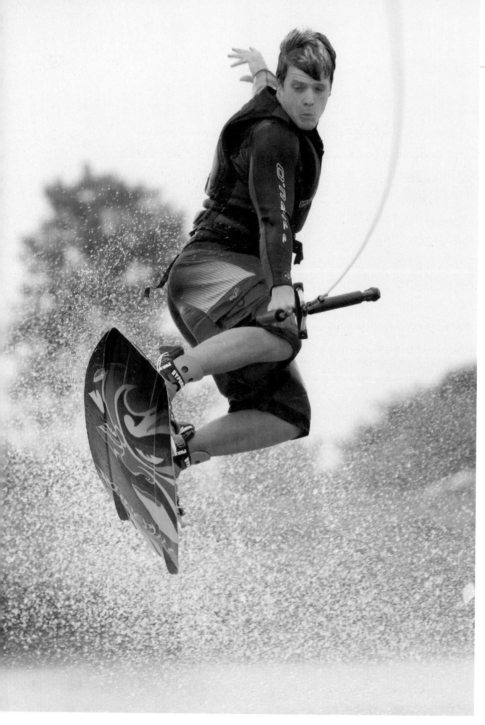

▲ FIGURE 10.3: Part of taking a good sports photo is knowing the sport's peak moments, such as a jump in water sports.

Know Thy Action

Every sport has a *peak* moment—that second when action erupts into a graceful flurry of activity. In basketball this usually happens at the hoop as someone goes for a lay-up or a dunk, or while offense and defense pirouette around each other mid-court.

Baseball's key action is usually centered around the slide into home plate, the pitcher's high-speed throw, and the swing of a bat (**Figure 10.3**). (Bonus points for capturing both the bat *and* the ball.)

Soccer and hockey center around fights for control of the ball or puck, while track events and other distance sports peak as the athletes cross the finish line or struggle to overcome each other for position.

Without understanding the rules of a sport, it's impossible to photograph it well. Professional sports photographers are usually fans of the sports they cover, using their understanding of the action to allow them to predict when key movements are going to happen.

Hang Time

Many point-and-shoot digital cameras, and a number of digital SLR (single-lens reflex) cameras, suffer from something called *shutter lag*. A camera's lag time is the length of time from when the shutter release button is pressed to the time when the photograph is taken. A number of conditions affect lag time, but the general rule of thumb is that the more expensive a camera is, the less lag time it has.

Lag time will affect your timing, so you'll need to practice with a few shots and see how quickly the camera can respond

(**Figures 10.4a** and **10.4b**). Flash-charging time is a big factor in camera shutter lag (the camera can't take a flash picture until the strobe is charged), so adjusting to a faster shutter speed and turning off your strobe may help speed up your camera's response time.

Seasoned professionals follow along with the action, raising their cameras at just the right moment to snap a photograph. Of course the cameras used by professional photographers tend to focus very quickly and are very responsive. A better method for most consumer digital camera users is to have the camera ready whenever anything is happening. Even if your camera has an LCD screen, look through the eyepiece viewfinder and *pan*

▲ FIGURE 10.4A: If you don't account for your camera's lag time, then chances are you'll miss a key moment.

▼ FIGURE 10.4B: By using any of several methods, such as panning along with the action, you'll be ready to capture the right shot at the right moment.

▲ FIGURE 10.5:
This unusual shot could not have been created from any other position.

around with the action. Using the viewfinder will eliminate distractions that might keep you from getting that perfect shot.

By partially depressing the shutter release button as the action picks up, you'll engage the camera's autofocus and metering systems, thereby preparing the camera to take a photograph when the moment is right. If the shot you're looking for doesn't happen, just release the shutter button and the camera will go back

to standby mode. Next time the action heats up, partially depress the shutter release again.

Get into Position

In sports, it's essential to be in the right place at the right time. The same is true with sports photography. You can't get a good shot of someone scoring a goal in soccer from the other side of the field. You can't take a picture of the winning home run from a position all the way up in the bleachers. You can't photograph a climber nearing the top of a peak from the base of the mountain (**Figure 10.5**).

Check out any professional sporting event and you'll see a cluster of photographers near where everything is happening. Even so, they're all still using long telephoto lenses to get really close to the action (see "Ready for My Close-up," below). They all know that their jobs depend on being at the right place at the right time.

Of course, your local Little League field isn't as coveted a venue as Yankee Stadium, so usually it's easier there to get a choice spot up close. It might mean walking away from the other parents to find a great photographic location (community sports planners don't always put the bleachers where the best action is), but the goal is to capture a great sports shot.

If you're photographing an individual sport or athletic activity, positioning is just as important. A shot of kayakers paddling down a river is cool, but if you can photograph from your own kayak, the shot is even better.

TIP

Always pack the right gear. Professional sports photographers carry bundles of gear—telephoto lenses, wide-angle lenses, multiple camera bodies, and more—with them in order to make sure they have the right equipment for the job. It's enough to give you a hernia, literally.

Now, I don't expect you to bring as much stuff with you, but there are a few things that might help you get a better shot. Pack a tripod or monopod, a telephoto accessory lens (if your camera accepts accessory lenses), and an accessory flash.

Zoom, Zoom

Most digital cameras have both an optical and a digital zoom. Sometimes you'll see "3X Optical 4X Digital" on the body of the camera, or maybe the camera will come with a sticker that says "12X Zoom," and then in fine print the manual explains which portion is optical and which is digital. Unlike optical zoom (which moves glass elements in the lens around to increase the apparent size of an object), digital zoom really isn't a zoom at all. It works by cropping out part of the image and blowing up what's left.

TIP

Never, ever let the PhotoCoaches catch you using digital zoom. Any good photo-editing program will let you crop your picture and enlarge it (with the end result being just as cruddy-looking as if you did it in the camera). But at least by using a photo-editing program you won't be throwing away photographic information contained in the original file.

Digital zoom usually needs to be turned on in the menus or by pushing a special button. A few cameras turn on digital zoom by default. Check your camera's menus to see if digital zoom is enabled (**Figure 10.6**).

Ready for My Close-up

If you've ever watched a tennis match, you've noticed the funny way that the crowd follows the ball. *Thwack!* All heads turn to the right. *Thwack!* All heads turn to the left.

When we watch sports, we're able to move our heads around and take in the whole scene. But when something exciting happens, we're able to mentally shut out the rest of the action and only focus on the key moment. Cameras can't do that, though—they have no idea what we're trying to photograph.

The key with action photography is to get in close, and then get in closer. Something strange happens when photographing sports—no matter how close you think you're getting, when you look at the pictures later, it's still not close enough.

▶ FIGURE 10.6: Make sure that digital zoom is turned off in your camera.

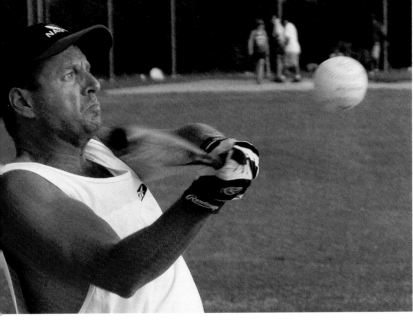

▲ ▼ **FIGURES 10.7A AND 10.7B:** Close-up shots of an athlete's facial expressions can be extraordinary as well as frequently entertaining.

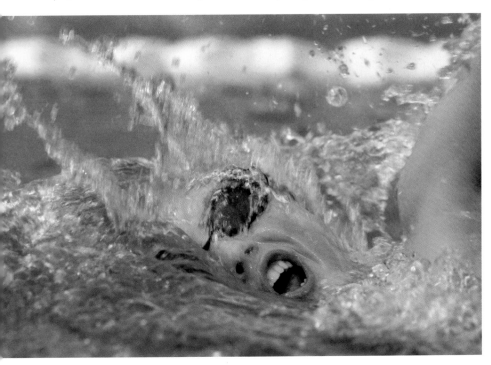

TIP

Look at an object across the room and stare at only it intently. Try to pick out some small detail on it. Notice how everything else in the room suddenly goes out of focus? Even though you can *see* everything in your field of vision, you're only *looking* at that object.

That's evolution for you—for millions of years humans had to look out over the grassy plains and think, "Is that a tiger over there, or a rock?" As a result we're very good at ignoring things that aren't important. The camera, however, doesn't have this type of selective vision, but instead photographs all objects at a given distance in the same way.

Some of the best sports photographs of all time have been composed entirely of the faces of athletes as they struggled to triumph over the odds (**Figures 10.7a** and **10.7b**). Now, I'm not saying that you need to take pictures of your children cropped so tight that you can count their eyelashes, but you *should* try to think about your composition when taking an action shot (**Figure 10.8**). Remember that when it comes to action, *the excitement is in the details*.

A problem for many photographers is that point-and-shoot cameras don't have lenses that zoom in close enough to really capture some sports scenes, and they don't all take accessory lenses. Digital SLR users have an advantage, as they can switch out lenses to match their needs. So you might need to move closer to the action to get your tight shots. If you can't get any closer, and your camera can't accept a telephoto accessory lens, then take your peak-action shots as close as you can, and crop them later in your photo-editing program.

▲ FIGURE 10.8: Close-up shots don't always need to consist of faces in order to tell a story.

▶ FIGURE 10.9: Use a wide-angle lens when you want to capture both the subject and his or her surroundings for excitement.

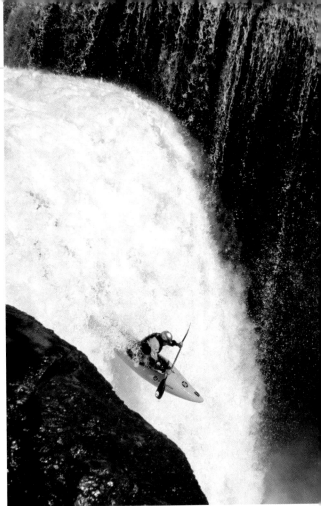

Go Wide! Go Wide!

No matter how important it is to focus on the action in a photograph, sometimes you've got to go with a wide shot. Not because the action isn't always important, but because sometimes what's going on can't be contained in a teeny space.

Many sports are dramatic enough that they can be captured in an engaging way using a wide-angle lens. Think of a group of track-and-field runners sprinting to the finish, each reaching out to cross the line first. Or kayakers plunging down waterfalls with water crashing all around them (**Figure 10.9**).

Sometimes the background or location of a sport is part of what makes it so interesting, and that's your chance to use a wide composition to frame the action. If the background tells a story, and your subject is part of a larger event, try photographing with a wide angle (**Figure 10.10**). Even though most of the time you'll find that a nice tight shot works best, you're certainly not limited to taking only those types of shots. Don't worry about experimenting with your view options to find something that's exciting.

▼ FIGURE 10.10: Shots taken with a wide-angle lens are also smart when you want to use the background to help tell a story.

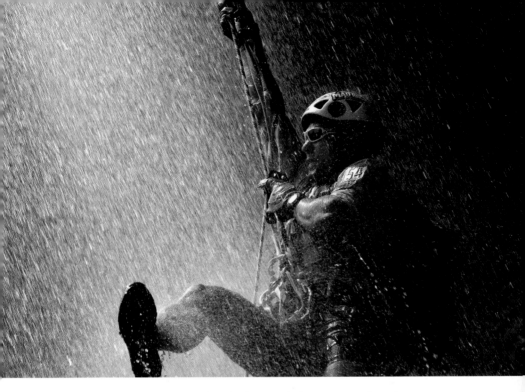

▲ FIGURE 10.11: Freezing an action in time can help you appreciate the power of an athletic maneuver.

Make It Quick

Most sports are fast and exciting—it's the quick pace and flurry of activity that attract participants and fans alike. Even sports with periods of relative calm like baseball can suddenly explode in a flurry of activity. The lightning-fast action makes them enjoyable to watch and photograph.

Cameras have the unique ability to freeze action in place, slicing a moment in time into a period as short as 1/8000 of a second. Think of how quick a second is, and now try to imagine something 8000 times faster. The precise, laserlike, time-stopping capabilities of a camera allow us to appreciate the grace and power of an athletic maneuver by freezing it in time (**Figure 10.11**).

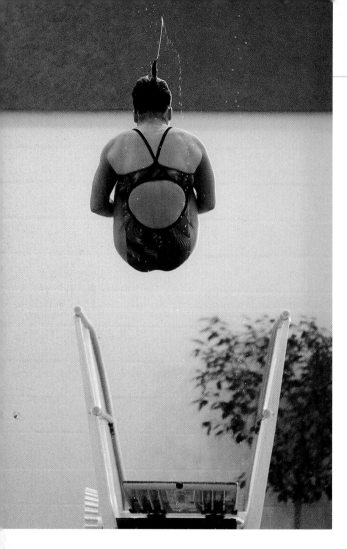

◀ **FIGURE 10.12:** Shutter Priority mode combined with a fast shutter speed will help you take crisp action photos.

▶ **FIGURE 10.13:** Sports mode forces your camera to use a high-speed setting to freeze action.

It's this superhero-like ability to freeze time that makes sports photography so appealing. Thus you'll want to maximize your camera's clock-stopping prowess by making sure you're shooting in the right modes.

If your camera supports Shutter Priority mode, then use it and set your camera's shutter speed to 1/125 of a second or faster. That's a speed that will capture most sports well, though it might produce a slightly blurry image for some really high-paced activities. Set the shutter speed to above 1/500 of a second and you'll likely be able to capture a crisp in-action photo (**Figure 10.12**).

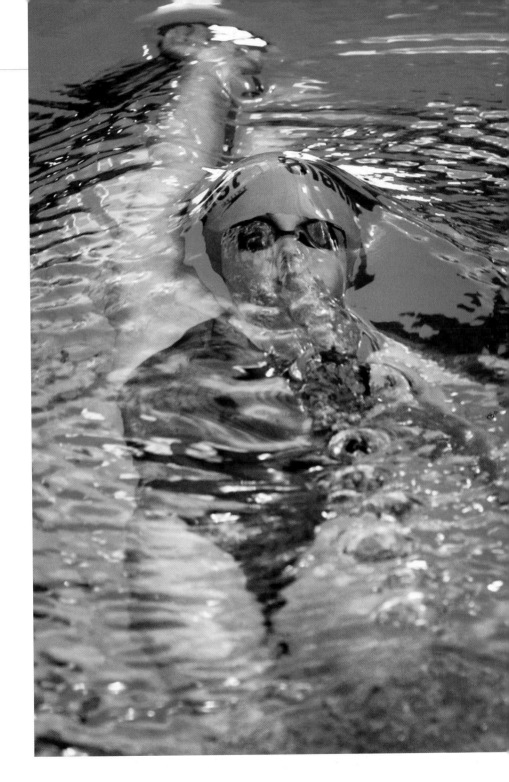

If your camera doesn't offer a Shutter Priority mode, have no fear. Simply turn to your Sports mode (it usually is indicated by a picture of a stick figure running), and the camera will use a high-speed setting that is fast enough to catch a fast-moving swimmer (**Figure 10.13**).

▼ ▶ FIGURES 10.14A, 10.14B and 10.14C:
All three of these photos dramatically show the speed involved in bike racing in an instantly recognizable way.

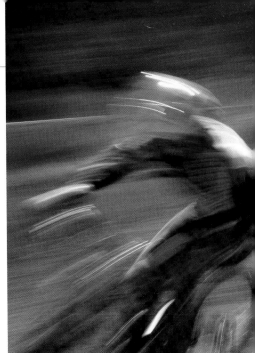

Take It Slow

Many times, professional photographers will intentionally shoot a fast-moving activity at a speed that's a bit slower than what is needed to create an action-stopping photo. This technique helps provide a sense of movement for the viewer (**Figures 10.14a, 10.14b,** and **10.14c**).

Stopping the action with a fast shutter speed works well, but sometimes it works *too well*, resulting in a photograph in which the subject seems to be standing still, even if it is moving incredibly fast.

By using a slower shutter speed (anything below, say, 1/125 of a second, depending on the speed of the person or thing you're photographing), you'll end up with a photograph with regions that are out of focus. Things that don't move much (baseball fields, roads, soccer stadiums) will be sharp, but the subject will blur, which automatically says, *That thing was moving pretty fast*.

▲ FIGURE 10.15: Set your camera to a slow speed and follow the motion of your subject in order to create a photo with a sharply focused subject and a blurred background.

TIP

A good rule is to make sure some portion of your subject is in focus, preferably the face. It's hard to connect to the motion of a photograph if 100 percent of it is blurry.

Try *panning* for an interesting shot—set your camera at a slow shutter speed (or set it to a slower mode, such as Landscape), and follow the motion of your subject with your camera while you press the shutter release button halfway down. If you time it *just right*, keeping the subject centered in the frame as you move to follow it, you'll end up with a photograph in which the background is blurry but the subject is tack sharp (**Figure 10.15**). Usually cool colored streaks will form in the background where you've panned past larger objects—these streaks really convey a sense of movement.

For an advanced technique, combine panning with fill-flash to create a unique image with background blur and sharp

foreground action (**Figure 10.16**). This technique works best with strobes that give you control over the flash's power or timing, since you'll want to turn down the brightness of the strobe or set it to go off for only a portion of the time the shutter is open in order to get your fill-flash-enhanced image.

It takes some practice to get to know your shutter speeds and your camera's settings well enough to get a good, yet blurred, photo. Don't be disappointed if your first attempts look like abstract art—you can tell people you meant for it to look like that.

▼ FIGURE 10.16: Also, combine panning and fill-flash to get a sharp foreground and blurred background.

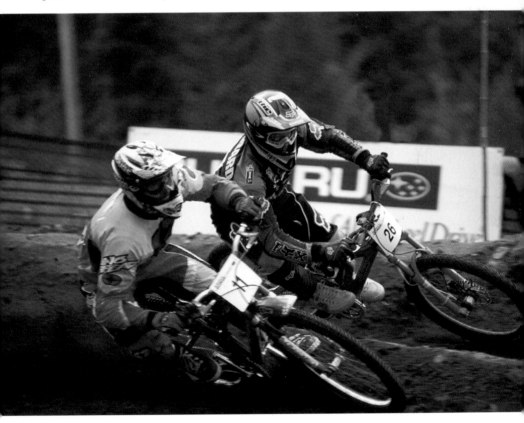

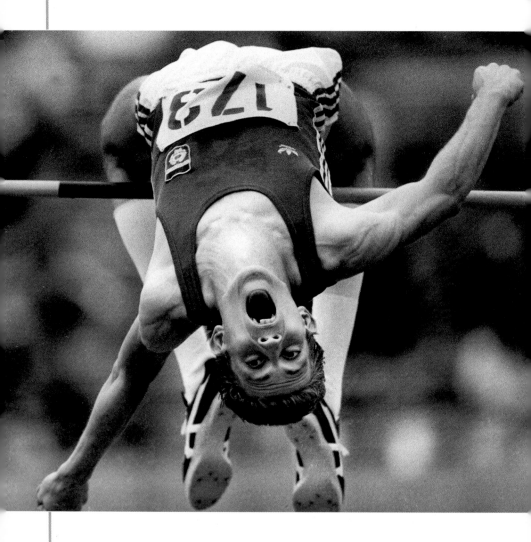

Capturing a Peak Moment
An unusual position created an unusual shot

In 1983 Nick Didlick made a memorable photo of a high jumper at the World University Games in Edmonton, Alberta, which he was covering for the United Press International (UPI) wire service. Didlick got the shot by combining good anticipation and sports knowledge with keen observation, the right lens, an unusual shooting position, and the appropriate shutter speed.

Didlick was covering the Games with fellow UPI photographer Gary Hershorn (now with Reuters), and the two of them tried an experiment. "We decided that one of us would do the standard angle, the standard shot [of each event]," says Didlick, "and the other one would look for something different, something that people maybe hadn't seen before. So for the high jump, I said, 'I'll look for something different.'"

While Hershorn shot from the typical spot to the side of the high-jump bar, Didlick wandered around the venue watching the action. Eventually, he saw Yugoslavia's Novica Canovic take his first jump. "I watched him do this unbelievable backflip, totally unorthodox style, eyes bulging, tongue hanging out, everything. I said, 'I've got to do something with this. Chances are he'll do it again.'"

Didlick had noted that Canovic's unusual backflip style took him more or less straight over the bar with his head pointed straight down. The best angle, Didlick figured, would be to shoot straight at the high-jump bar with the jumpers running toward him.

To get that position, Didlick ended up in the field area, where he had to keep an eye out for javelins, hammers, and other flying objects from the other events going on simultaneously.

He mounted a 600 mm lens on his camera. "In sports [photography], you're watching for that one peak of action," Didlick says. "So I thought, 'If I use that lens and get as close to the bar as I can, I can fill the frame up. You'll be looking at this guy full face as he comes over the bar.'

"So I aimed straight toward the bar and gauged where he was going to come over it. Then I focused on the bar and pulled the focus back toward me slightly. And then I just waited for him to run into the frame and jump. He came over the bar in the right place and I pushed the button."

To get that position, Didlick ended up in the field area, where he had to keep an eye out for javelins, hammers, and other flying objects from the other events going on simultaneously.

Didlick used a shutter speed of 1/1000 of a second to freeze the moving action, which allowed every straining muscle and sinew to show up sharply.

Though Didlick got some great feedback on the picture from his New York editors, he figured that was the end of it. "Canovic was not a high finisher, so I thought nobody would run the photo," he says. But an unusual shot can sometimes win over a hard-bitten photo editor, and the Portland *Oregonian*, not previously known for its interest in also-ran Yugoslav high jumpers, printed the picture across the top half of its sports page the next day. —EAMON HICKEY

CHAPTER 11

How to Take
Artistic Photos

You've Learned All the Rules

Now It's Time to Break Them

UP UNTIL NOW I've talked a lot about using digital cameras to take pictures of friends and family, to document important events in our lives, and even to capture the high-speed action at a sporting event.

Sure, I've talked about ways to make your photographs more beautiful, creative, and interesting. But in each case I've talked about ways to get fantastic photos as a means to some other end—for example, using your camera and your newfound skills to produce better portraits of your mom, create interesting shots of your children playing sports, or document your family's trip to some fun-filled vacation spot.

But cameras are unparalleled creative tools, as they can capture the world around you in ways that no other medium can. In the 1800s painters and other artists decried the invention of photography, worried that the accuracy of the images would detract from the value of other artistic forms. (Who is going to pay thousands of dollars, they reasoned, for a painting of something that only *looks* like a lake when a photograph can capture it perfectly?)

But a camera is more than a tool to document an event or to capture the likeness of someone you know. Think of a camera as being part paintbrush and part canvas—a device that can open up new areas of creativity. And with digital photography there are no boundaries to the experimentation you can do. From macro photographs of flowers to full-blown landscapes and everything in between, there are countless ways to take an artistic picture. Of course, there's no exact definition for what makes a picture "artistic" rather than just plain beautiful.

The Creative Sort

Many people define something as being artistic if it's been done simply for the sake of creating something appealing. To them, a news reporter on assignment to photograph local kayakers might create interesting images, but they wouldn't necessarily be artistic because the photographs are being used to illustrate a story.

Some people take *artistic* to mean *beautiful*, looking for some inherently attractive condition that lifts a picture from being a photograph and transforms it into a work of art. A photo of kayakers floating on a bay at sunset might be artistic if it makes someone appreciate the beauty of nature and the grace of the kayakers (**Figure 11.1**).

▼ FIGURE 11.1: Beautiful shots such as this one of kayakers at sunset can be considered artistic as well as meaningful.

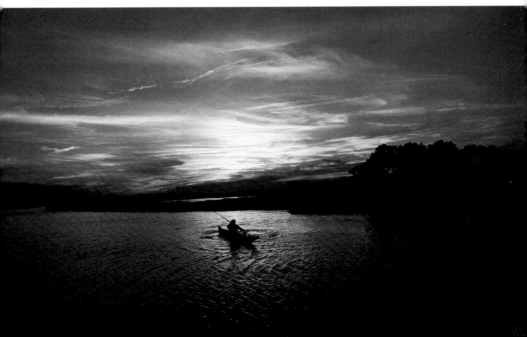

To other people, *artistic* means *emotional*, referring to a piece of work that conveys more emotion than information. Closely related to beauty, this sort of artistic photograph speaks to viewers on a certain level, maybe bringing them back to childhood or making them nostalgic for some other time. The beauty of the bay and the kayakers might make one long to paddle on the open water, even if kayaking skills are lacking (**Figure 11.2**).

▼ FIGURE 11.2: For some people, artistic shots are ones that bring back memories or make one long to try something new.

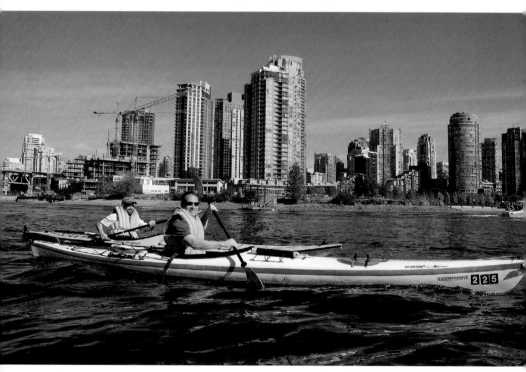

▲ **FIGURE 11.3:** Abstract images such as this one of a kayaker's paddle reflected in water have long been considered artistic.

Finally, many people connect *artistic* with *abstract* and consider an image artistic only if it's difficult to recognize yet emotional or beautiful. A picture of the curve of a kayaker's paddle shimmering with water while suspended above blurry reflections in a lake would be considered truly artistic by these folks (**Figure 11.3**).

To the PhotoCoach, though, these images are all artistic in their own right. In art school a long time ago, one of my teachers introduced the theory that *art is the byproduct of doing something creative*. Some art is good, some is bad, but as long as a photograph is taken in the process of being creative, it's artistic.

We're going to focus on some of the types of artistic photos that are most interesting, to show you how you can easily turn photography into art.

Become an Artist in Five Easy Steps

If there's one thing that art school teaches you, it's how to survive on nothing but a can of soup a day. If, however, there are two things that art school teaches you, it's how to survive on soup and how to see things in a *creative* light. Art students are encouraged to look at the world in different ways to see the beauty that is all around. Here are some of the best ways to get into an artistic mind-set:

• Instead of looking at things as being objects (building, fork, hamster), try to see them for their shapes, colors, and textures (square, shiny silver, furry). Look though your viewfinder or LCD screen for things that catch your eye for their creative qualities. Take a picture of the angular roof of a building, the yellow leaves of a flower, or even the texture of a manhole cover (**Figures 11.4a** and **11.4b**).

• Look for contrasts; try to find areas where two different-looking objects come together. Point your camera's lens at shapes that have creative, differing patterns. Even if you can't tell what

◄ **FIGURE 11.4A:** Bright colors and unusual viewpoints combined can make the ordinary extraordinary.

► **FIGURE 11.4B:** Try to look at buildings for their shapes or for unusual details, such as the curving pipe on this structure.

◄ **FIGURE 11.5:** The contrasting patterns of the leaf and the lichen make for an exciting photo.

▶ **FIGURE 11.6:** This photographer opted to focus on the open space between the parts of the Ferris wheel, thereby creating a much more interesting photo than just a straight shot.

the objects in the photograph are, the combination is often exciting (**Figure 11.5**).

• Photograph *negative space* instead of positive space. What's negative space? Think of a Ferris wheel with the arms and baskets being the positive space in the image. Now think about the areas *between* the arms of the Ferris wheel. As in that famous optical illusion with the two faces and the vase, photographing something's negative space can often prove to be more interesting than photographing its positive space (**Figure 11.6**).

• Set your camera to a different mode and see what happens. Instead of shooting in automatic, maybe choose the sports mode and then photograph portraits while using it. Or set the camera to landscape mode and shoot sports. The idea is to try new things, and let the accidents create the artistic images.

• Take pictures all the time. The more things you photograph, the more artistic you'll become, and the better your chance not only of stumbling on something artistic but also of being ready when an artistic opportunity arises.

▲ FIGURE 11.7: When shot at a macro level, snow on a flower bud (top left) or rain on leaves (top right) can radically transform the way we see a plant.

Starting Small

Sure, big is beautiful, but some of the most fascinating things in the world go on without our even noticing. Take flowers, for example. Every day the flowers in your garden undergo dramatic transformations. Petals that are closed and wet with the morning dew slowly open and turn toward the sun. Pollinating insects visit for a nice snack while inchworms slowly travel up the stem. At night, the leaves fold shut while the tender bud prepares for another day. Rain, sunlight, even the occasional early-season snowstorm can radically transform a flower (**Figure 11.7**).

A *macro* shot is a photograph taken of something small, where the subject is slightly magnified (not as much as a microscope might enlarge it) in order to make a more interesting picture. Flowers aren't the only good macro subjects; anything teeny and often overlooked will do (**Figure 11.8**).

▲ **FIGURE 11.8:** A close-up of this small hood ornament on a car provides a bright and compelling view.

Some cameras have a special macro setting, which enables them to focus on very small objects held very close to the lens. Look for the macro icon (it's a small flower, get it?) on the camera or on your camera's menu. Some digital cameras can use special macro lenses that let you focus on really small objects. Digital SLR cameras need special lenses to make a really small object look good.

The macro world is a fascinating one, not just because we usually pass by small things in our daily lives, but also because the shapes and color are so interesting. A macro shot can encompass all the creative styles from abstract to emotional. Looking at a hidden world in a new light can be very moving, even if we can't identify the subject.

TIP

I see you sitting there with your head several feet above the ground and your tush in that comfortable chair. You can't get a good appreciation of the macro world from all the way up there. To scout out good macro photos, the PhotoCoach has crawled around under trees and beneath skyscrapers, climbed into caves and the trunks of cars, and has spent countless hours getting dirty, wet, or covered in all kinds of stuff. Put the book down and look around the floor for a while.

Breaking All the Rules
(All the Photographic Ones, Anyway)

Since we started with the small world of artistic photographs, let's work our way up the scale and stop at objects and people next. In previous chapters we talked about composing your pictures (Chapter 2), photographing your family (Chapter 9), photographing people while they're moving (Chapter 10), and more. Now forget all of that. (Don't *really* forget it all, of course, because then you'll have to go back and start reading from the beginning. Instead, get ready to break some of those rules.)

Sure, you can use all the rules I've taught you to take an artistic photograph. Heck, that's what the PhotoCoach is here to do. Good composition, good lighting, and good subjects are the centerpieces of any high-quality photograph.

But artistic pictures don't have to conform to those rules. In fact, some striking examples come from breaking the rules. When taking artistic pictures of people or things, look for ways to take an *alternative* photo. In other words, instead of focusing on poses or depth of field or white balance, focus on the subject as if it were the heart of a painting. Try to find the curves, the colors, and the elements of the person or thing that sets that subject apart (**Figure 11.9a, 11.9b,** and **11.9c**).

Here are some artistic ways to bring a photo to life:

- Look for ways to portray people in a different light. Integrate them into their background so that they stand out in contrast, illuminate them in a way that highlights an overlooked feature, or approach the photograph with a reverence or a humor or

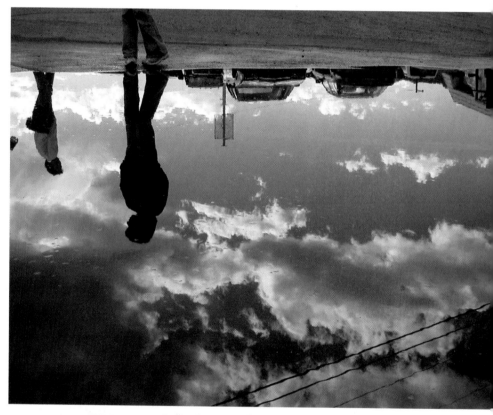

▲ **FIGURE 11.9A:** Reflections can often make creative photos, whether they are reflections of other people or...

◀ **FIGURE 11.9B:**
...reflections of yourself.

▼ **FIGURE 11.9C:** In
many cases, a photo
taken just because it
has interesting colors
and textures can look
almost like a painting.

▲ FIGURE 11.10: Capturing people in a different light, for example by showcasing their shadows, can add emotion to a photograph.

other quality that is not usually part of the subject's personality (**Figure 11.10**).

- Find different ways to present everyday objects. A fire hydrant is just another everyday object until the bright red color and the angular shapes become the subject of the photo (**Figure 11.11**). Or, taking an alternate route, use the fire hydrant and some brilliant lighting as the background for a portrait of your family's dog.

- Look for the fine detail in an object. The wrinkles in an old man's face or the cracks in a weathered old fence, or small type on a sign can make compelling images (**Figure 11.12**).

▼ **FIGURE 11.11:** You wouldn't normally think of a fire hydrant as a work of art, but in this photographer's eye it became one.

▼ **FIGURE 11.12:** Even the most ordinary details such as text on this sign can make an interesting photo.

Landscaping Without a Shovel

Nature's beautiful vistas have long been a favorite subject for artists. The grandeur of this planet is breathtaking, and artists have striven to capture that glory in every medium that's ever been invented. Cave wall, paper, canvas, film, and now CCD have all been repositories for beautiful nature images.

And no wonder nature makes such a great subject—it's beautiful without needing makeup, usually provides its own lighting and backdrop, and doesn't fuss around while you're trying to take a photograph.

All too often, though, landscapes look bleak or boring. A mountaintop vista turns into a long blurry line of green. What is that? Trees? Snowscapes become monotone parodies of a photograph—some big expanse of white with maybe a speck or two of color where a tree pokes its head out of the icy covering.

TIP

That blurry mountaintop I just mentioned? It would have been tack sharp using a tripod (Chapter 12) and shot with the right f-stop or with the camera's sensitivity changed to a higher ISO (Chapter 3).

The trick is to think creatively. Find ways instead to make your landscape photograph represent what is different and unique about the particular vista that you're capturing. Often the thing you want to focus on is the thing that first captured your eye. Perhaps the mountain shot *should* be blurry and out of focus so that it highlights the changing pastels of colors in a fall day. Maybe the tree poking its head from the snow bank is the only interesting part of the photograph.

Landscape in a Jiffy

Taking creative photos of a landscape doesn't have to be hard. In fact, if you can just remember to think about the following seven alternatives, then you'll be well on your way to creating beautiful landscapes. Here's what your PhotoCoaches suggest:

Think contrast. Look for elements in your scene that really jump out at you. Think of the blue of the Caribbean Sea against the white sands of the beach or a fireball-red sunset against a dark background. Look through your viewfinder or use your LCD screen, panning around until something jumps out at you.

Think wide. Some landscapes need to be big—really big. Majestic mountain ranges, winding rivers, the multicolored rocks of the Southwest—all of them say, "I am big. You appreciate me because I am big. I do not translate well to being small." When the picture calls for *big*, think *wide*. Set your camera to its widest zoom setting to capture as much of the scene as possible. If your camera's zoom can't go wide enough, check to see if your camera can use an accessory wide-angle lens (Chapter 12), or use your panorama mode (see "Stitch by Stitch," below).

Think narrow. Some parts of nature are so interesting they deserve their own photograph. Isolating them in a picture highlights them and sets them off from otherwise distracting elements (**Figure 11.13**).

Think aperture. Mastering your camera's f-stops (see Chapter 3) will help you make artistic landscapes. Look for places to blur backgrounds to create interesting contrasts, to force multiple objects into focus, or to render the entire photograph completely in focus (**Figures 11.14a** and **11.14b**).

▶ FIGURE 11.13:
Some objects found in nature have interesting patterns that deserve to be highlighted.

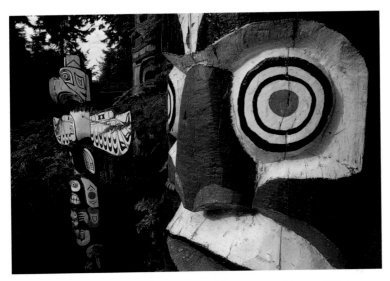

▲ **FIGURE 11.14A:** Mastering your camera's aperture settings will help you control the outcome of your photo. Here the photographer used f/16 to keep all the objects in focus.

▼ **FIGURE 11.14B:** With a setting of f/3.5 the background blurs, directing the eye to the front-most totem.

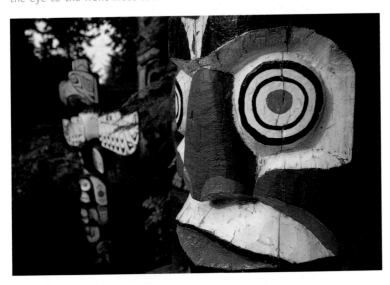

Think focus. Landscapes don't need to be razor sharp. In fact, you may intentionally want to blur a landscape. Most point-and-shoot digital cameras, however, lack a manual focus mode that would allow you to do this. (Photographers who use a digital SLR camera can simply turn the focus ring to intentionally blur a picture.) Point-and-shoot users can take advantage of a trick—press and hold the shutter release button halfway while pointing at something a few feet from the camera (make sure you're using a wide aperture for this to work), and *without* releas-

▼ **FIGURE 11.15:** You can trick your digital camera into taking a blurry but beautiful picture.

ing the button, point the camera at your landscape and then press the button. Voila! A blurry photo, for art's sake (**Figure 11.15**)!

Think lighting. Lighting can make or break a landscape. The light during different seasons—and even at different times of the day—can really change the way something looks. Lighting creates colors; colors make things pretty; pretty makes for a good photograph. Bonus tip: Almost nothing looks good in the harsh light of noon. With the sun directly overhead, colors are washed out, shadows are cast on objects, and things look generally, well, yucky.

Think white balance. Don't like the colors that nature is providing? Use your camera's white balance setting to change the way things look (see Chapter 3). Shift from warm tones to cool tones and vice versa by changing the white balance setting.

Stitch by Stitch

Thanks to the modern miracle of digital cameras and photo-editing programs, it's possible to create a landscape photograph that used to require complex and specialized camera gear.

Many digital cameras now feature a *Panorama mode* that stitches together a number of wide-angle photographs. Every camera's Panorama mode works a bit differently, however. Some digital cameras create a low-resolution panorama by taking the photograph using only a small segment of the CCD. Others let you take several photos in a row, and then in-camera software overlaps them to produce one wider picture. Finally, some cameras produce a batch of photos to be combined on a computer later, but they ensure that the exposure of each image is matched up right to prevent odd color patches when the files are merged.

Digital SLR cameras don't usually have a panorama mode, so digital SLR owners (and those folks whose point-and-shoot

cameras lack in-camera stitching) will need a software program to combine the images. Here's how it works using Adobe Photoshop Elements:

1. Choose Create Photomerge from the File menu.

2. The Photomerge dialog lets you open up the images you want to use. Use the Browse button to find the right pictures (**Figure 11.16**).

3. For most needs, you can simply check the Attempt to Automatically Arrange Source Images box. This works especially well for cameras with a good panorama mode, as the images generally line up enough for the program to find the edges and match the colors.

4. Sometimes things go awry, and it's easer to arrange the pictures manually. Simply drag the leftmost image of your panorama onto the working area. Next drag the second image in the series onto the first image so that you overlap the edges where your photographs meet (**Figure 11.17**).

▶ FIGURE 11.16: Choose the photos you want to merge.

▲ **FIGURE 11.17:** Drag the images onto your working area so that they overlap.

▼ **FIGURE 11.18:** The final panorama is so smooth that it looks as if it always was just one photograph.

5. Keep going until you've lined them all up. Then check the box that says Advanced Blending. This tells Photoshop Elements to apply special techniques to blend together all of the images in the panorama more thoroughly.

6. Click OK and watch as your panorama is created in front of your eyes (**Figure 11.18**).

Filing an Abstract

The final type of artistic photo is one that has more in common with Picasso than with Ansel Adams. (Ansel Adams was one of the greatest photographers of all time. If you don't know his name, you've still seen his pictures—his majestic black-and-white landscapes were captured with elaborate and heavy equipment he would carry out into the field.) Abstract art looks at the world as a collection of shapes and colors rather than as solid

▼ FIGURE 11.19: The swirling colors in this abstract photo evoke emotions even if you can't recognize the photo's subject.

objects. The aim of abstract photography is to make the photograph simply evoke emotions without the viewer's necessarily recognizing what's in the photograph. Swirling blurs of colors, arrangements of shapes, and even pictures manipulated with ultralong or ultrashort exposures are all examples of abstract photography (**Figure 11.19**).

It Effects Me Greatly

Finally, tucked in the menus of most every digital point-and-shoot camera—and many digital SLRs—are some special powerful effects settings such as black-and-white mode, sepia mode (which imitates old-school photographs and the way they looked when printed), starburst, and more.

Never, ever let the PhotoCoach catch you using these effects.

The data that your imaging sensor captures is priceless. Once you snap a picture of something, you'll never be able to take the same picture again. Each of the special effects takes your original photograph and manipulates it in a *lossy* way. The black-and-white mode throws out all the color information, while the sepia mode not only throws out the information but it also then *adds* brown to the picture. Any of these effects eliminates something from the original file. It's like drawing on a film negative with a marking pen—and your PhotoCoach knows you wouldn't do that!

Every photo-editing package on the market includes tools for creating special effects, so it's always a better idea to open your file in an editing program, save a copy of your image using Save As from the File menu, and then make changes. This will preserve your original image and allow you to play with effects without regretting your choice someday.

Flash Forward
Flash and long shutter speeds create a ghost-like streak

In November 1999, the *Calgary Herald* assigned Rob Galbraith to shoot the picture that would run alongside a profile of a local middle-distance runner. Galbraith used a special flash effect called *rear*, or *second, curtain flash sync* to make the shot.

"I've always been interested in different ways of mixing both flash and ambient light, and how that can change and jazz up a photo that might otherwise look static," Galbraith says. So rather than make a standard picture of the runner on a track at noon, Galbraith decided to shoot at night, after 10 p.m.

Galbraith took three photofloods—powerful tungsten lights not unlike standard household floodlights—and set them up on light stands along one stretch of the track. These would provide constant illumination as the runner ran by, but if Galbraith used a long shutter speed such as 7 or 8 seconds, as he planned to, the runner would appear as a streak through the frame.

Galbraith also set up a flash on a light stand in a position where the runner would be moving toward it. This would provide one sharp, frozen image of the runner when the flash fired. If the flash fired at the beginning of the 7-second exposure, the sharp image of the runner would show up in the final picture at the tail end of the streak, which is visually unnatural. So Galbraith set his flash to fire just before the shutter closed—at the end of the 7-second exposure—ensuring that the streak would trail behind the sharp part of the image as we expect to see it. This is rear-curtain flash sync (so named because a camera shutter is composed of two curtains; the first, or front, curtain opens to start the exposure, and the second, or rear, curtain closes to end it).

"The trickiest part of making the picture was closing the shutter with him in the right place [in the frame]," Galbraith says. To ensure that he got the composition right, Galbraith took the time before his subject showed up to jog through the set a few times while triggering his camera remotely. "Those pictures are hysterical. I just look like a total knob. So I can say for sure that to make this picture work, you need a real runner, not a middle-aged overweight newspaper photographer." —EAMON HICKEY

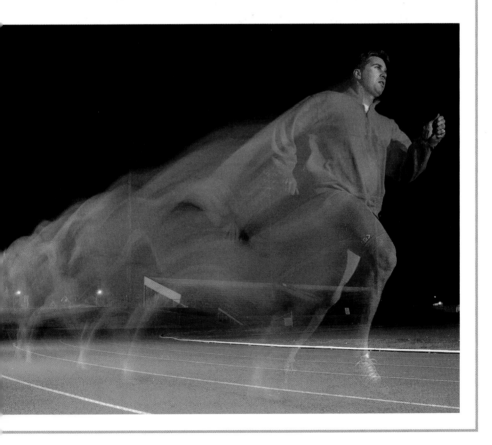

Abstract Painting
This piece of art is really a photo of a pool taken with a point-and-shoot camera

Nick Didlick used a simple trick to turn a dull shot into a good one while visiting Houston, Texas, in the spring of 2004. He was in Houston teaching the Nikon School of Digital Photography with a colleague, and he found himself with an hour to kill between his turns at the lectern. Didlick had just received a little Nikon Coolpix 3700 point-and-shoot camera to test, and he walked over to check out the indoor swimming pool at the hotel where the school was being held.

"I looked out at this swimming pool," Didlick says, "and there's daylight coming in through the windows. The cross members from the windows are casting shadows on the water, and it was making these beautiful lines and patterns. But the water was this ugly sort of pea green.

"I took a picture with the camera set for all auto, and it looked ugly. But I knew if I changed the camera's white balance from auto to incandescent it would change that daylight into really rich blue colors. So I took the picture that way, and it changed the water to this beautiful deep blue with these striking black lines across the pool. It turned out to be one of my most favorite images. So now I keep one of these little point-and-shoots with me nearly every-where I go."

—EAMON HICKEY

How to Trick Out Your Camera

There's a Store
Full of Gadgets
Just Itching to
Come Home
with You

OVER THE LAST COUPLE HUNDRED pages I've talked a lot about photography and about all the great things you can do with a digital camera. No doubt you noticed that on more than one occasion I mentioned using some sort of accessory.

Photography is a very gear-oriented activity, and it's easy to get caught up buying all sorts of gadgets in order to extend your photo-taking possibilities **Figure 12.1**). Since you really need a computer to maximize your digital photography experience, a whole other world of doodads and geegaws is open before you.

▼ **FIGURE 12.1:** It doesn't take many accessories to open up a whole new world of picture-taking possibilities.

"Great," you're thinking. "I just want to take pictures and now I've got to go out and spend a fortune on little add-ons." That's far from the case, though. Digital cameras are sophisticated little devices, and the vast majority of them are so much more refined than their film counterparts that most photographers will never have to buy anything else to take a good picture.

Still, if you're looking to expand your photographic possibilities, there are a handful of items that can really help make photography easier, can keep you shooting longer during any given session, or can help you take more creative images.

I Can See Clearly Now

A camera is just a box designed to collect light. I remember a science project in school when I was a youngster, where we created a camera by taking an oatmeal container (painted black inside and out) and putting a hole in the front with a pin, which we then covered with electrical tape. In a dark room we placed a piece of film against the back of the container and took the contraption outside. Uncovering the hole for a fraction of a second exposed the film, and we ended up with a photograph.

In the oatmeal-box camera, the little pinhole was all we needed for a lens. Camera lenses are the eyes of photography, and a lot of technology goes into developing them. (Not so much into the whole-grain hot cereal box cameras, though.) The little zoom lenses in point-and-shoot cameras are really very sophisticated and they do a great job.

But some shooting situations are beyond the scope of the little compact lenses in point-and-shoot cameras. For that reason,

there are a variety of accessory lenses available to extend your shooting possibilities. Not every camera accepts attachable lenses, so if you'd like to use one when shooting, it's good to look for that feature when shopping for a camera (or when upgrading to a new camera).

Digital SLR cameras either have interchangeable lenses (**Figure 12.2**), or threads on the front that accept screw-on lenses. It's this versatility that make them so popular with advanced amateur photographs.

Digital SLRs with interchangeable lenses can use either zoom or fixed focal length lenses. A fixed lens has just one length,

▼ FIGURE 12.2:
Digital SLR cameras offer photographers a lot of versatility because they use interchangeable lenses.

▲ FIGURE 12.3: A zoom lens provides a range of distances which you can use for shooting.

◀ FIGURE 12.4: Not every point-and-shoot camera can accept add-on lenses, but those that do, require lenses that screw onto the camera body.

measured in millimeters. It only provides you with one fixed viewpoint. A zoom lens gives you a range of choices for composition, allowing you to change how your picture looks with just one turn of a dial (**Figure 12.3**).

Accessory lenses for point-and-shoot cameras have to screw onto the main lens (**Figure 12.4**), but not every camera has the ability to accept screw-on optics. Generally speaking, the more compact (or less expensive) the camera, the less likely it is that you'll be able to use add-on lenses.

The screw-on lenses used with point-and-shoot cameras don't offer zoom capabilities, so I'm not going to talk about zoom specialty lenses here. Just know that in each of the lens types (wide angle, telephoto, and macro, which are discussed in "The Big Picture," below), there are zoom versions available for SLR users.

▶ **FIGURE 12.5:**
There's a reason they call these lenses *wide-angle*!

The Big Picture

For capturing a nice landscape or other scenic vista, nothing beats a wide-angle lens (**Figure 12.5**). These lenses take your camera's widest settings and make them even *wider*. A wide-angle lens will enable you to capture sweeping views up to 180 degrees.

A category of specialty lens called *fish-eye* takes the wide-angle thing even further, making your pictures look as if they were shot through the peephole in a door **Figures 12.6a** and **12.6b**).

Far, Far Away

On the opposite side of the spectrum from wide-angle lenses are telephoto lenses, which are designed to magnify your field of view and allow you to shoot faraway objects as if they were much closer.

Telephoto lenses are the workhorses of sports and news photographers—they enable you to get pictures of faraway subjects without your having to actually move any closer to them (**Figure 12.7**). Nature photographers love them, too, because they make

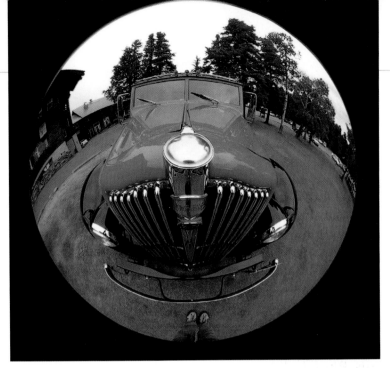

▲ **FIGURE 12.6A:** This classic car was photographed with a fish-eye lens attached to a compact camera.

▼ **FIGURE 12.6B:** Here's the same shot except this time we zoomed in closer to the car with the camera.

it easier to take photos of skittish animals or scenes that are too far away or on terrain that is too rough to walk on.

Up Close and Personal

You've probably seen photos of patterns on butterfly wings or the stamens in a flower. You can thank a macro lens for these shots (**Figure 12.8**). Another favorite of nature photographers and other folks, macro lenses let you take pictures of small objects magnified so as to make their tiniest details photographically interesting. Macro lenses allow you to get close to your subject and have it appear to take up the full frame. Think of a macro lens being like a low-powered microscope attached to your camera.

◄ FIGURE 12.7: Telephoto lenses are perfect for taking photos of distant subjects when you can't actually move closer to them physically.

▼ FIGURE 12.8: Photos such as this extreme close-up of the stamens in a flower are taken with a macro lens.

Improve Your Memory

Just about every digital camera on the market these days comes with a memory card that—there's no nice way to say it—just plain sucks. In order to save money, the manufactures ship their cameras with these puny little cards that barely hold any pictures. It might have been OK to ship a 16 MB or 32 MB card with a 2 megapixel camera, but in these days of higher pixel counts these little suckers are as useless as lips on a chicken.

There are several types of memory cards available, and depending on the kind your camera uses (and your budget) you can get cards as large as 8 GB (**Figure 12.9**). The most common memory card formats are CompactFlash, SD, xD, and MemoryStick. You can only use the type of memory card designed for your camera. (Look on the card that was included—the sticker will tell you what variety it is.)

▼ FIGURE 12.9: Memory cards come in a wide range of sizes from 16 MB up to a whopping 8 GB.

Larger memory cards are a great purchase, because they let you shoot longer without having to head back to your computer. Some vacation travelers even purchase several cards so that they can be on the road for days or weeks at a time without needing to connect the camera and download images.

The Juice Is Flowing

Modern digital cameras are really just sophisticated computers in disguise. Every time you push the shutter release button, they run through trillions of little calculations. They have to figure out the exposure, set the shutter speed, determine flash power. Phew, it's hard to be a camera.

All that thinkin' uses a lot of power, and for digital cameras power comes in the form of batteries. Some models use standard AA batteries while most use rechargeable cells that are designed specifically for your particular camera model.

If your camera uses rechargeable cells and also comes with an external battery charger, you can leave one battery plugged into the charger while shooting with the second battery (**Figure 12.10**). When the battery in the camera gets low, simply swap them out. If your camera plugs directly into a wall outlet, charge one battery and then take it out of the camera and put it with your camera gear. Then charge up the second battery and shoot with it. When that battery gets low, switch to your spare.

Reading Is Fundamental

In Chapter 5 we talked about the process of transferring images from camera to computer, and about the usefulness of having an external card reader.

Here's a refresher for you in case you've forgotten: Every camera comes with a cable that allows you to transfer images to your computer. That cable usually transfers data very slowly (using a standard called USB 1.1). As long as your camera is plugged in and turned on, it's using battery power. So, using the cable that comes with your camera forces you to sit around and wait while images transfer, and it kills your battery.

An external card reader uses a faster connection (USB 2.0 or FireWire) to speed up the image exchange process, and doesn't draw power from the camera (**Figure 12.10**). Less wait, no battery drain.

Look for a card reader that accepts a number of different memory card types (some handle up to eight different memory card standards) so that you can use it with other people's memory cards, and can continue to use it if you get a different camera.

External readers are available with both USB 2.0 and FireWire connectors. Computers made within the last few years have both USB 2.0 and FireWire, but USB 2.0 is a safer bet for PC users while FireWire is found on more Macs.

TIP

A USB 2.0 card reader uses the same plug as USB 1.1, so it can also be used on a computer that only supports USB 1.1, albeit at the slower speeds.

▲ **FIGURE 12.10:** An external battery charger (top left) lets you recharge one battery while you continue shooting with another. With an external card reader (top right), you can simply pop out a card of images from your camera, stick it into the reader, and quickly transfer images to your computer. A hot shoe (bottom right) lets you slide add-on flash units onto the camera.

Back in a Flash

With a whole chapter of this book dedicated to using flash effectively, it's not surprising that I recommend looking into an accessory flash. The built-in light sources in most cameras can handle a lot of shooting situations but just aren't powerful enough or configurable enough for really artistic photography.

If your camera has a flash hot shoe (a metal bracket that a flash unit slides into), you can use an external unit to add more light and more versatility to your shooting (**Figure 12.10**). Camera companies all make flash units recommended for their particular

cameras (and it's often a good idea to just purchase that model), but a number of companies make third-party flash systems that will work with any camera.

Digital SLR cameras have a number of advantages over point-and-shoot cameras, but one of their most compelling is the ability to work with accessory flash units. (Some, but not all, digital

▶ **FIGURE 12.11A:** This point-and-shoot camera has a strobe attached to its hot shoe via a flexible cord.

▼ **FIGURE 12.11B:** The photographer took this photo of the Korean War Memorial in Washington, D.C., from one angle while having a friend walk to the right holding a flash that was triggered at the end of the exposure, thus lighting up the statues and flag from the side.

▲ FIGURE 12.12: In a professional studio setting, photographers use large diffusion screens to soften the light on a subject. You can get smaller versions for your camera's flash.

point-and-shoot cameras also have this ability. Some digital SLRs come with built-in strobes, these aren't nearly as powerful or as versatile as an accessory unit making the use of an add-on flash even more compelling. What's more, the sophisticated brains inside digital SLRs can communicate with the add-on strobe units, controlling their light output to more perfectly match the needs of a scene (**Figures 12.11a** and **12.11b**).

Accessory flash units also accept light-modifying devices, such as diffusion screens and other reflectors that allow you to modify your light like the pros (**Figure 12.12**). The cream of the crop in flash units pivot to allow you to point your light exactly where you want it, and some of them swivel as well, allowing you to create effects by bouncing your light off of things like walls or ceilings.

▲ FIGURE 12.13A: This photo of a flower was taken without any special light-modifying devices.

The PhotoCoaches travel with lots of devices to control the light that's falling on a subject (**Figures 12.13a**, **12.13b**, and **12.13c**). The most popular are reflectors (used like mirrors in order to bounce light from a flash or other light source onto someplace else (such as a subject's face) and diffusers (used to soften the light falling on the subject). It's easy to make these things yourself, though. A sheet of cardboard covered in tin foil makes a great reflector, and a thin sheet of cloth held between the strobe and the subject makes an excellent diffuser.

◀ FIGURE 12.13B: Here the photographers are setting up to retake the photo with a two reflectors that will work together. One will bounce light onto the flower and the other will act to soften the light and create a nice flow of shading.

▼ FIGURE 12.13C: The end result is a photo with far more pleasing colors and shading.

Hold Still

Vibration causes blur, and blur ruins a photograph. It's not always possible to hold a camera perfectly still, though—for example, when it's windy or very cold you may have a hard time keeping your hands perfectly still. Also, when you need to take a shot with a long exposure, say at night, there's nothing you can really do to keep the camera absolutely motionless so that you don't introduce blurriness into your photo.

The solution? Use a tripod, the one accessory that no photographer should be without. Everyone has seen a tripod, but few people own one, or at least a good one. Ideally a tripod should be sturdy and supportive, but not so heavy that it's difficult to carry around.

The legs of a tripod should be easy to extend, and should stay in place when locked. A variety of locking mechanisms exist, and some people prefer one system to another, so experiment with a tripod, extending and contracting the legs, before you purchase it.

There are several types of tripods, spanning the range from lightweight "travel" models, designed to be taken on trips or stashed in the car, all the way up to super-heavy professional models designed to hold massive cameras or lights.

Some people go out and purchase the heaviest tripod they can find, figuring that the weight of the unit will eliminate vibration. It's not necessary to spend a fortune on a heavy-duty professional tripod if you're using a point-and-shoot camera (**Figure 12.14**).

Look for a sturdy tripod that's designed to handle the maximum weight of your camera gear. For a point-and-shoot user that's going to be around a pound, but for digital SLR users that could be as much as 20 pounds.

Tripods come in a variety of different materials as well—magnesium, aluminum, steel, and carbon fiber are all frequently used as materials. There's no "perfect" material, so don't be persuaded to spend a lot of money on a carbon fiber tripod because it's lighter and stronger than steel (although it is) if all you need is a camera support for the occasional landscape photo.

Likewise, tripod heads (the part of the tripod that attaches to the camera and allows it to turn and pivot) come in all different varieties (and at a good camera store can be purchased separately from the tripod itself). Some have adjustment knobs, some have locking rings, and some have handles that work like a pistol grip. As with tripods themselves, you can spend a fortune, but all you need is a good solid unit that won't slip during use (**Figure 12.15**).

There's a lightweight and easy-to carry alternative to the tripod that's popular with sports photographers—the monopod (**Figure 12.16**). Composed of a single leg with an attachment

◀ **FIGURE 12.14:** A lightweight tripod is just fine for steadying a point-and-shoot camera.

▼ **FIGURE 12.15:** Tripod heads come in all shapes and sizes but all you really need is a solid unit that won't slip out of position during use.

that mounts to the camera, a monopod provides a bit of stability but also allows the photographer to move around. Monopods are interesting choices for someone shooting high-speed sports, especially in low light, or looking for a lightweight way to shoot nature photography.

▼ FIGURE 12.16: While you probably won't be shooting with a lens quite as large as the one being used by the pro in this photo, you might very well opt for a one-legged tripod (called a monopod), which provides both stability and portability.

Pack It Up, Move It Out (Rawhide!)

Once you've gotten an assortment of camera gear (or even if you decide to stick with just the camera alone), you'll need something to carry things in.

There are an almost unlimited number of camera bags, ranging from small custom-designed pods intended to cradle just a point-and-shoot camera all the way up to gigantic padded carrying cases designed for the pros.

Cameras and their accessories are a delicate bunch of gear so it's a good idea to get a case that has a fair amount of padding and doesn't leave a lot of room inside for objects to bounce around.

▼ **FIGURE 12.17:** There's a camera bag for every situation, whether you want a backpack-style case for a day excursion or something larger and sturdier that can better handle the rigors of travel.

Many photographers take the approach of using several bags—a small and light pack for a day trip (**Figure 12.17**) and a larger bag for travel or vacation.

TIP

Small point-and-shoot cameras are designed to go in a pocket, but they are still delicate enough to require padding. On a trip to Europe once I accidentally walked into a metal pedestrian barrier with a nice, expensive digital camera in my pocket. Not only did I bruise my leg, but I shattered the fragile LCD screen on the back of the camera, too. Take a tip from the 'Coach—protect your gear.

Put It in Gear

Just about the only accessories we think are must-haves are a camera bag and at least one large memory card. Beyond that, it's up to your personal taste, budget, and artistic inclinations to start adding to your gadget list. Professional photographers generally have one (and often two) of everything they can think of, and while that's great for being prepared to take photos in absolutely any kind of situation, it can also be a hassle to pack and carry all that gear (not to mention trying to get through airport security—and you thought your shoes were a problem!). So take your time, get to know your camera, figure out what kinds of photos you take most often, and then plunge into the world of accessories.

All Geared Up

Keeping your gear watertight, even in a deluge

Reed Hoffmann got a very wet reminder of how important the right accessory gear can be during the Eco-Challenge Fiji adventure race in 2002. He was part of the Blue Pixel team photographing the race for the TV broadcasters USA Network and Sony AXN, among other clients. Hoffmann was dropped into the high jungle by helicopter to cover the action over a mountainous section of the course, where competing teams would climb up and rappel down steep cliffs and dodge water-falls, among other adventures.

It started raining right after he arrived, and the deluge lasted for two days. Hoffmann had no choice but to keep shooting despite the miserable conditions. He was carrying two pro cameras, several lenses, and a laptop computer, and keeping all that stuff dry while also doing his job was a big challenge. When transporting or storing his gear, he used an Ortlieb dry bag, a completely submersible backpack-like sack. When shooting, he used a Lowepro DryZone waterproof camera back-pack and a regular old umbrella.

"An umbrella is not a sexy tool, but it's one of those essentials," Hoffmann says. "You can do a lot of work under an umbrella unless it's windy." He says he generally wedges the umbrella handle against his chest with an elbow or forearm, allowing him to use both hands on the camera.

Using his combination of rain-fighting gear, Hoffmann took hun-dreds of pictures during his two days in the mountains. He cites one picture, taken at the top of a ridge, that was typical of the way he worked. "The contestants had to make their way up this steep, slip-pery incline," he says. "With the gray clouds and rainy mist in the background, I thought it would have this nice sort of lonely look.

So I waited in the rocks at the top of the climb, huddled under my umbrella in my rain gear. You're basically just miserable. Eventually one of the racers came along in the right spot at the right time, and I made the shot."

Hoffman ended up stuck in the mountains for the length of the rainstorm, and the Ortlieb dry bag proved its worth in dramatic fashion when he finally made his escape. The weather had prevented helicopters from coming up to bring him out, but on the morning of the third day it looked as though the rain might clear. So Hoffmann stuffed his gear into the Ortlieb bag and headed for the landing area.

"By 3 p.m. there's still no chopper," Hoffman says, "and I'm getting really depressed. I'm going to be stuck in that mess for at least another day. And then I heard it—a helicopter was coming up the canyon." Because of where the pilot landed, Hoffmann was forced to wade across a waist-deep river.

"To get to the passenger side," he recounts, "I have to cross in front of the chopper. I'm sort of hugging the passenger compartment bubble, wading through this pool, and right as I get in front of the

pilot the river bottom just drops off. I hit a hole and go completely underwater. Because of all the air trapped in my backpack and rain gear, I popped right back up, and I look through the windshield and the pilot is laughing so hard he's practically falling out of his helicopter.

"Now I'm not very happy at this point, but at least I'm getting out. And then the radio in the helicopter goes off. The pilot and his spotter wave me away from the chopper, and they take off. You can't print what I'm thinking as they fly off.

"It turns out they had an emergency medical evacuation—one of the racers was sick. But they must have taken pity on me, because they stopped and picked me up on the way back out. When we landed at the main camp, it was 80 degrees and people were wearing flip-flops. I'm soaking wet from head to toe, but when I opened up that dry bag, there wasn't a drop of water in it. All my gear was dry."

—EAMON HICKEY

Index

hobbies, 209–210
Hoffmann, Reed, 130–131, 294–296
hot shoe, 285

I

images. *See also* printing images; sharing photos
 adjusting size of, 140–141
 archiving and searching for, 106–108
 avoiding special effects for, 269
 backing up, 101–105, 108
 browsing, 98
 burning CD of, 102, 103
 capturing landscapes, 22
 compensating for poor lighting, 28–29
 conveying motion in, 220–221, 236
 cropping, 14, 20, 22–23, 114–117, 227
 deleting, 96
 experimenting with angles, 18–19, 30–32, 198–199
 exporting to Web host, 150
 exposing, 35–36
 flash's effect on color of, 74
 focusing on object of interest, 13
 framing in photo, 15–17
 getting closer to subject, 20–22
 image formats, 97–98, 139
 lifetime of, 182
 megapixels and image size, 164–169
 naming and organizing, 93–96, 106–108
 rule of thirds, 24–25
 sharpening, 175–176
 size of, 137
infants, 204–206
ink, 168, 182
inkjet printers
 cleaning, 178
 dpi counts for, 165, 166
 input and output resolution for, 166–167
 photographic quality, 168, 170
 printing with, 158–159
 testing output of, 178, 179
input resolution, 166–167
iPhoto. *See* Apple iPhoto
IPTC (International Press Telecommunications Council), 97–98
iris, 40, 43
ISO speed, 49–53, 60

J

Jasc Paint Shop Pro, 117, 171, 172, 177
JPEG image format, 139

K

keeping camera handy, 195, 250
kids. *See* children

L

lag time, 223–224
Landscape mode, 48
landscapes
 adding interest to, 260–261
 adjusting white balance, 265
 focus and, 264–265
 lighting and, 265
 panoramas, 261, 265–268
 wide-angle lens for, 22, 261
lenses
 aperture size and focal length of, 44
 fish-eye, 278, 279
 interchangeable, 275–277
 macro, 281
 switching, 230
 telephoto, 227, 278, 280–281
 wide-angle, 20, 21, 22, 231–232, 261, 278
 zoom, 277
light meters, 79
lighting
 accessories for, 287–288
 artistic photos and, 255, 258
 available, 37, 69, 201–202
 color balance, 202
 conveying mood with, 198, 201